lo-fi Photo Fun!

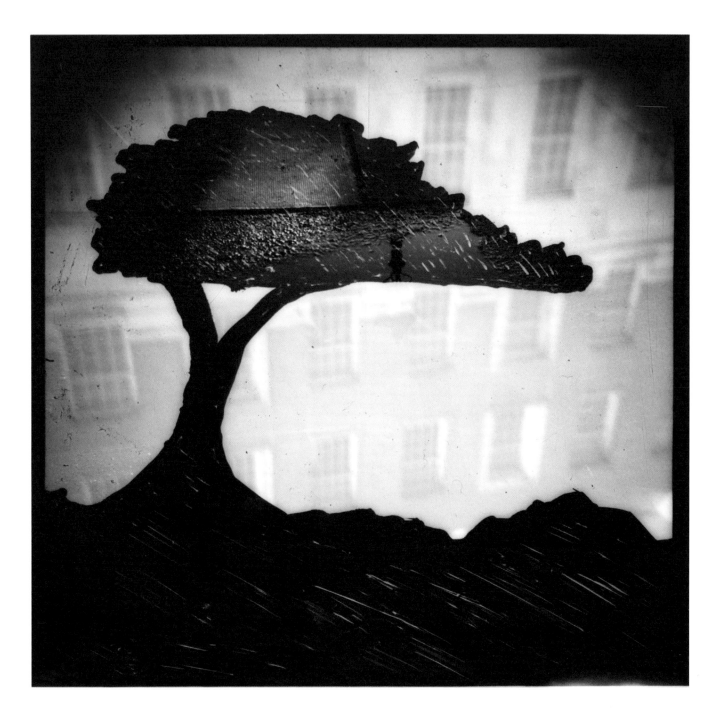

lo-fi Photo Fun!

LEARNING
RESOURCES
CENTRE

Adam Bronkhorst

Creative Projects for Polaroid, Plastic and Pinhole Cameras

APPLE

CONTENTS

INTRODUCTION

This book has been written with the aim of opening up to you the wonderful world that is analog photography. There are many different projects you can try, with all sorts of cameras. Some are easy, and some are more challenging. But all of them are great fun, and the creative possibilities are endless.

This isn't the definitive guide to projects with film cameras. I haven't covered every topic in great detail, but this book has been designed to show you some of the great things that you can do with some film and a camera. If you really want to find out more about a project, it's well worth doing some research yourself. Use this book as a starting point—find something that interests you, and go for it.

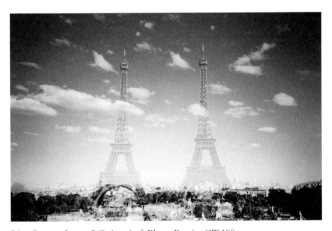

Lisa Garner, Lomo LC-A+, AgfaPhoto Precisa CT 100

TYPES OF CAMERAS

Throughout this book there are a few types of cameras used, but some appear more than others. If you haven't got a film camera and are looking to get one, there are a few good places to start:

LOMO LC-A

This is a plastic 35mm point-and-shoot film camera, first made in Russia in 1984. Thanks to the Lomographic Society, it has become a cult camera, due to the wonderful images it produces and its sheer simplicity. The Lomo LC-A is really fun to use and light to carry around. You can do quite a few of the projects in this book with it. There are also many accessories for the Lomo LC-A that can help you experiment.

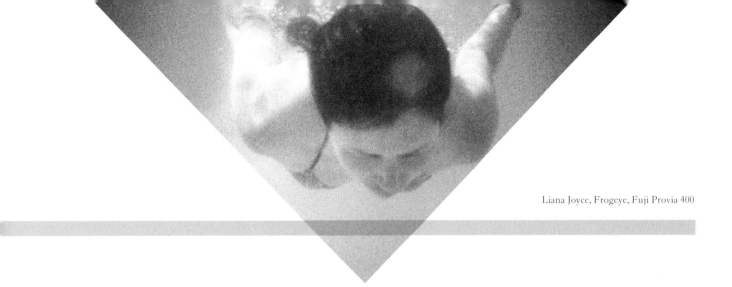

Liana Joyce, Frogeye, Fuji Provia 400

HOLGA 120

This camera was first made in Hong Kong in the early 1980s and was designed for the Chinese mass market. It takes 120 medium-format film and is a very basic camera made almost entirely of plastic. Even the lens in some Holgas is plastic. It's the fact that the Holga is so cheap and simple that makes it so loved. This camera has the power to produce some stunningly beautiful photographs evoking a sense of emotion, which you just don't get with a digital camera. (The Diana is a similar 120 camera, but you can't modify it as well as the Holga.)

SINGLE-LENS REFLEX (SLR) CAMERA

A film photography fundamental. At some point, if you're into film, you'll own an SLR camera. There's just so much you can do with one. An SLR is one of the most versatile cameras you can buy, as you can change the aperture, shutter speed, and lens. Quite a few projects in this book use one.

GET CREATIVE

Although this book is all about projects with film cameras, feel free to adapt them and use a digital camera if you want to. Many techniques will cross over very easily from format to format.

Photography isn't about film or digital; it's about the photographer. The camera is just a tool to convey an idea. So pick up yours and get creative. Do it now. What are you waiting for?

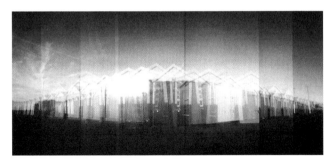

Simon Tomlinson, PinHolga, Kodak Ektachrome E100G

Projects for film

SHOOTING SPROCKETS | GALLERY

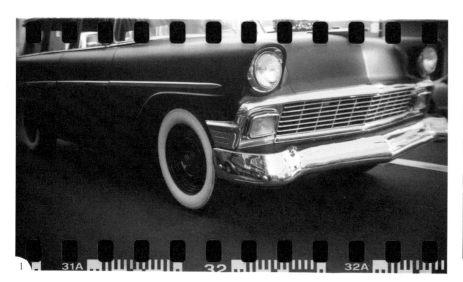

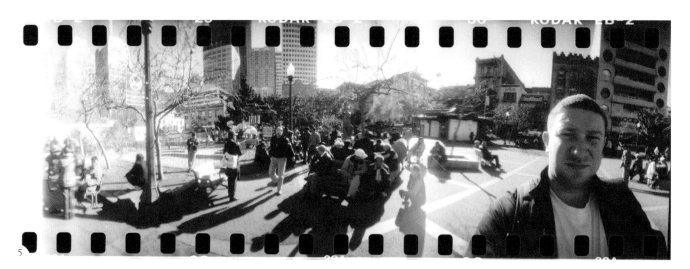

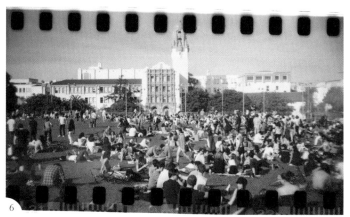

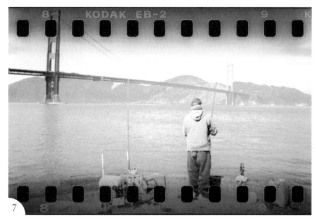

Projects for film
SHOOTING SPROCKETS

With this technique, you expose the area along the outside edges of 35mm film in order to capture the sprocket holes, frame numbers, and film details in your image.

▶ HOW IT WORKS

The light-sensitive emulsion on 35mm film covers the full width of the negative—including the area around the sprocket holes that are used to wind on the film. When you expose these areas through sprocket-hole photography, you'll get a lovely lo-fi effect.

All you need to do to shoot the sprockets is to load a camera designed for medium-format 120 film, like a Holga, with 35mm film. There are some cameras out there that are able to shoot the sprockets as a special feature; others are totally geared toward sprocket-hole photography (see Types of Cameras, right).

▶ WHAT TO DO

As 120 film has lightproof backing paper, unlike 35mm, you'll need to stop light from leaking into the camera. Block the film counter window on both sides with insulation tape—it's best to tape up the window on the inside and outside to be sure.

Next, tape the beginning of a roll of 35mm film onto an empty 120 film take-up spool, place the film into the left-hand side of the camera, inserting a piece of foam above and below the canister to keep it in place. Place the spool into the right-hand side of the camera, and close up the back.

With your film counter window taped up, there's no way of knowing how many shots you've taken or where the next shot is, so you need to count the number of clicks when you're winding the film on. It normally takes about 32 clicks to get you to the next frame. But as your take-up spool gets full of film, it'll take less winding to advance the frame.

When you reach the end of your film, use a darkroom or a lightproof bag (see page 169), to manually rewind the film back into the cartridge. After that, you can get your 35mm film processed as normal.

SCANNING

Most lab processing machines are set up to scan just the standard part of a 35mm film and not the sprocket holes. For best results, you should scan the film yourself.

You'll need a scanner that can cover the full width of the negative. Usually, 35mm film holders for scanners won't allow for this. Try making your own negative holder, or weigh the negatives down with coins so they don't curl, or scan the negative between two pieces of glass (such as those found on a photo frame), or use a 120 film holder. Lomography have released two masks specially designed for sprocket scanning.

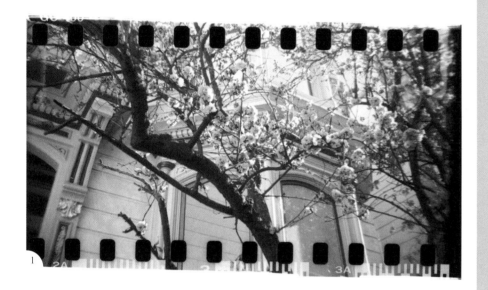

1

2

TYPES OF CAMERAS

SPROCKET ROCKET
Billed as the first analog camera to be
fitted with a reverse gear. This allows you
to rewind your photos and shoot over
them again. The Sprocket Rocket is also
fitted with a super wide-angle lens, and
allows you to shoot the whole width of
your 35mm film over the sprockets.

SPINNER 360
We'll cover this unique camera in the
panoramic cameras section on page 106.
But it also shoots the whole width of
the negative.

BLACKBIRD, FLY
A twin-lens reflex 35mm (TLR) plastic
camera, meaning it has two lenses, one
for the waist-level viewfinder and one
for taking the photo. Most TLRs shoot
120 film, so the Blackbird, fly is pretty
special in this respect. You can shoot in
three different formats—standard 35mm
format; with a square mask for square
images; and without the masks, the entire
width of the film with the sprockets.

Projects for film
INFRARED | GALLERY

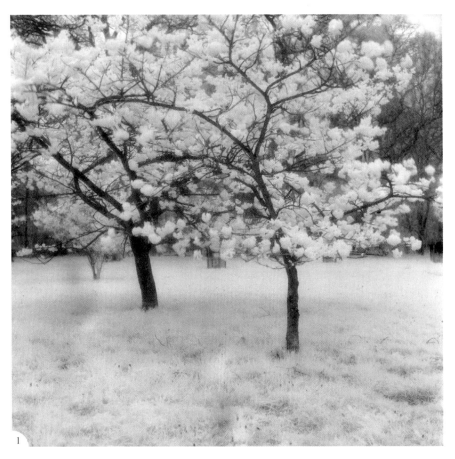

1

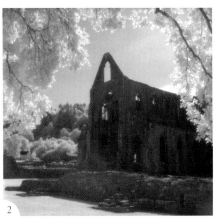

2

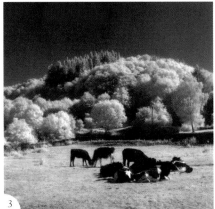

3

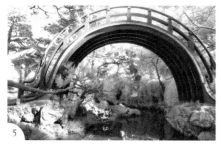

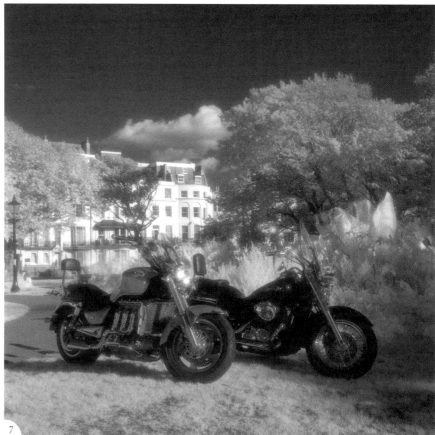

INFRARED

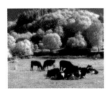

Shooting infrared film with a filter can give special effects, allowing you to capture a whole spectrum of light not normally visible. Whatever kind of photography you prefer, it'll give surprising results.

▶ HOW IT WORKS

Infrared film captures wavelengths of the light spectrum that the human eye can't see, so the resultant images tend to look unusual. Color and black-and-white infrared film is available online and in camera stores, though it can be expensive. In addition to the film, you'll need an infrared filter on your camera that looks black or deep red. This blocks out most or all of the visible light spectrum but allows infrared light through.

▶ WHAT IT CAN DO

If you're into landscape, architecture, or still life, I'd highly recommend trying infrared film, as your pictures will take on a very different quality. In fact, whatever you're into, it's worth experimenting, as you never know what the results will be like.

Trees and foliage reflect lots of infrared light, so green leaves will look white. Deep blue sky has very little infrared light, so it will look very dark, while clouds will have lots of contrast. And portraits can have a unique look and feel, as infrared wavelengths penetrate a little way into the skin and give it a milky look.

▶ WHEN SHOOTING

Shooting with infrared film and filters can be tricky. The filter is so dark that once it's attached to your camera, focusing and framing will be virtually impossible. A way around this is to focus and frame before you attach the filter to the lens.

Exposure is the most difficult part of infrared photography, as you won't be able to get a reading through your camera or through a standard light meter.

Use the guidelines that should be supplied with your film to bracket the exposures, and try a bit of guesswork.

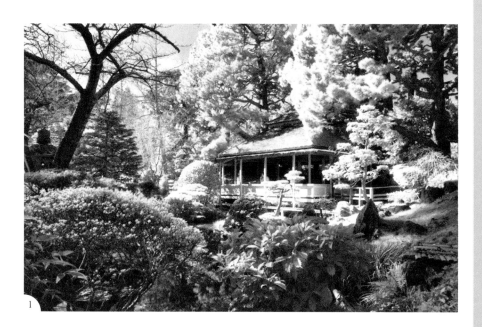

1

⏵ WATCH OUT FOR

You should take every precaution to make sure you get the best results with your film. This means that it's probably best to load and unload your film in total darkness and not open the film canister in light. Any stray light may damage your film.

Your lab should be able to develop infrared film with the same process as black-and-white. However, always inform your lab that you've shot the film as infrared. As some labs use some infrared equipment to see what they are doing in the dark, this could damage your film.

It's possible to develop your own film at home, and each film manufacturer will provide guidelines, but the key with developing infrared films yourself is to be consistent with your development process and learn what works and what doesn't.

TYPES OF FILMS

ILFORD SFX 200
This is probably the easiest film to get; it has an extended red sensitivity and is very affordable.

EFKE IR 820C
This film is made in Croatia by a company called Fotokemika. It has a very deep sensitivity and is highly recommended.

ROLLEI INFRARED IR400
Rollei's Infrared 400 film offers true IR sensitivity with very fine grain and is also capable of reversal processing (where positive transparencies are produced from black-and-white negative films).

COLOR INFRARED FILM
Unfortunately, it seems that color infrared film is no longer manufactured. You may be able to pick up the odd roll on Internet auction sites, but expect to pay more for it.

Projects for film
REDSCALE | GALLERY

1

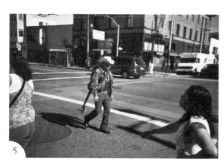

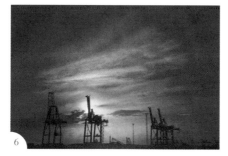

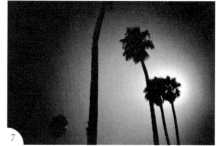

Projects for film
REDSCALE

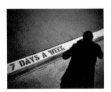

Get intense red, orange, and yellow tones in your shots with this quick and easy project. All you need is an empty and a full film spool, some tape, scissors, and a lightproof bag or darkroom.

▶ HOW IT WORKS

With redscale, color film is exposed from the wrong side of the emulsion, i.e. through the back of the film. So film has to be loaded onto the canister back to front. The name *redscale* comes from the strong color shift to red that is typical when you use this film. This is because the red-sensitive layer of film that's usually on the bottom of the film is now exposed first. The results can include intense red, orange, and yellow tones.

This technique probably came about as a result of someone loading film the wrong way around, and it's gained in popularity. Now, you can buy preloaded redscale film, but there's really no reason to, as you can make your own very easily.

▶ WHAT TO DO

Get two film spools: One should be empty with a little bit of film left on it, say, half an inch. (You can always ask your lab if they have any spare.) The second spool should be a new roll of film, which you want to use as your redscale film. Cheap or expired film (see page 163) works really well for converting to redscale. On the full spool, cut off the film leader (the little bit of film that helps you load your film into your camera) so that you are left with a straight edge. Then flip the spool over and tape the back of the full film (the matte side) to the front of the empty spool film (the shiny side). Make sure that you have a straight edge on both sets of film, so that they line up well. Then, in total darkness, or in a lightproof bag, wind the empty spool in so that all your film is transferred from the full spool to the empty spool. Cut the film off the now empty spool, leaving about half an inch of film on it, so that you can use that for your next roll of redscale. Cut a new film leader on the now full spool, load it in your camera, and get shooting.

▶ WHEN SHOOTING

Because you're shooting through the part of film designed to block stray light from getting onto the light-sensitive emulsion, your shots need to be overexposed by one or two stops, so if you're shooting with ISO 100, set your camera to ISO 50 to help with exposure. This makes it ideal for multiple exposure shots, and you can expose the film many times without getting an overexposed image.

◉ WHEN DEVELOPING

Again, your lab should be able to develop
this as normal color film. However, tell your
lab how you've shot your film, as this will
help them with the processing. If you've
made your own redscale film and have used
tape at the end of the film, please, *please*, let
your lab know. This can cause a big problem
with the lab's machines by clogging them
up with gunk from the tape.

As you may have used two totally different
film spools to make your redscale film, it's
always a good idea to write the ISO of the
film onto the film spool, so that your lab
knows how to process the film.

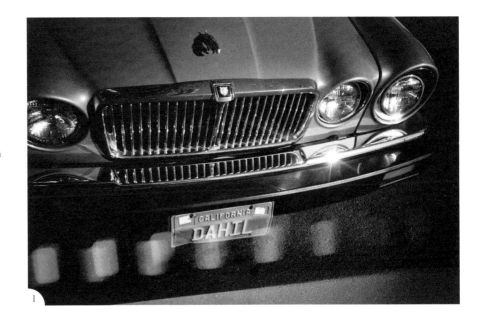

1

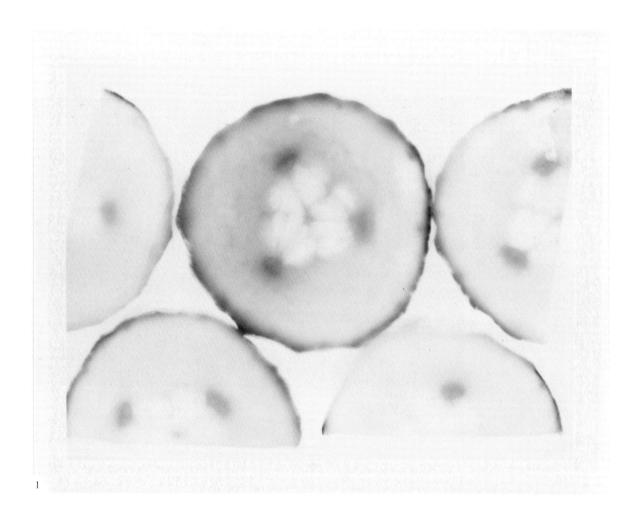

2

Projects for instant film
PHOTOGRAMS | GALLERY

1

1 Fuji FP-100C
2 Fuji Instax Mini
3 Fuji Instax Wide
4 Fuji Instax Wide
All photos on this spread by Adam Bronkhorst

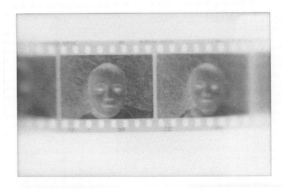

3

2

4

This is a new take on an old process, updated to use instant film instead of darkroom processing. Think small when you choose what objects to shoot, and the creative possibilities are endless.

▶ HOW IT WORKS

A photogram or instagram is an image that's been made by placing an object onto photosensitive material, which is then exposed to light. The result is a shadow effect, with different tones, depending on the transparency of the objects used.

This technique has its roots in the very origins of photography, back in the 1830s, and was used by early pioneers such as William Fox Talbot. But these days, you don't need photosensitive paper, developing chemicals, or a darkroom to capture your image. Instead, you can use instant film, as it already contains all the chemicals and processing you need to make your very own photograms.

▶ WHAT TO DO

For a photogram, you can use peel-apart film, or any of the Fuji Instax films (see page 164). You need a camera that works with these films (as you need to trigger the development process, and the best way of doing this is with the camera). A light source is essential as well—a flashlight or flashgun will do. And of course, you need an object to capture on the film, so think small here: anything that can fit onto your instant print. Cut-up fruit, leaves, flowers, or paper work well, but anything flat that'll leave a good silhouette, and won't let in light underneath, will work. Lastly, you need a very dark room, as all this needs to happen away from light.

Lay out everything you need where you can find it in the dark. Load the film into the camera, and switch the lights off. Open the back of the camera and take the film pack out. Place your object onto the instant print. Expose the print to a small amount of light, with a flashgun or flashlight. Place the film pack back into the camera. Fire off a shot, but cover the lens, so as not to reexpose your image. Switch the lights back on, and wait for your image to appear in front of your eyes. It will take a few tries to get right, but keep at it.

▶ WATCH OUT FOR

Be careful not to overexpose your image.
It takes only 0.01 seconds of daylight to expose
your print, so it's very easy to overdo it. I find
that a flashgun fired on its lowest power and
bounced off the ceiling works well.

Make sure your objects are flat against the
instant print, otherwise you'll get light creeping
in underneath. Some people use a piece of
glass to squish their subject down on the film.

You can also use paper (an image from a
magazine or a candy wrapper works well)
to get some color onto your photogram.
Just place it over your object so the light can
still shine through it. If you're going to use
something like fruit, or an object that may
damage your print, cover it in plastic wrap.

1

Projects for instant film
PEEL-APART | GALLERY

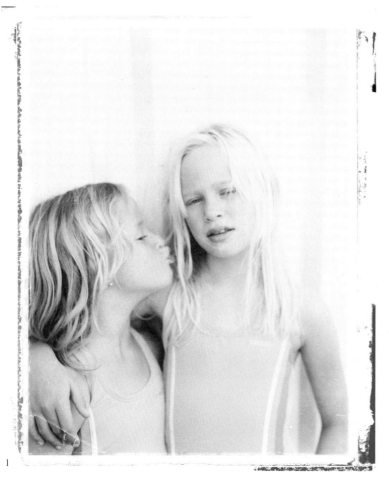

1

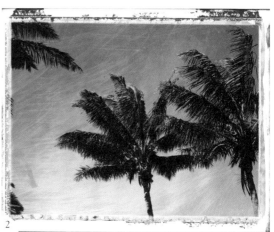

2

3

4

Projects for instant film
PEEL-APART |
GALLERY CONTINUED

1

1	Adam Bronkhorst, Polaroid 250 Land Camera, Fuji FP-100C
2	Wendy Laurel, Polaroid 600 SE, Fuji FP-100C
3	Adam Bronkhorst, Polaroid 250 Land Camera, Fuji FP-100C
4	Adam Bronkhorst, Polaroid 250 Land Camera, Fuji FP-100C

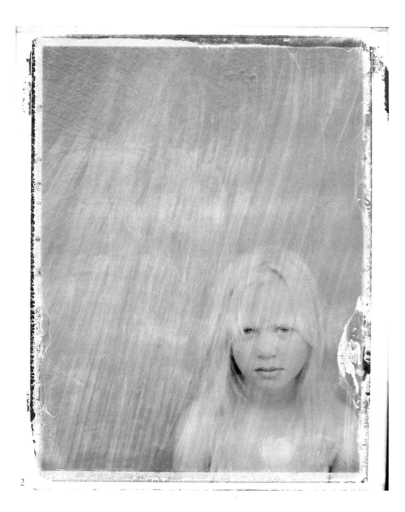

2

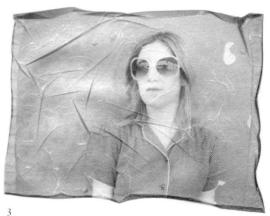

3

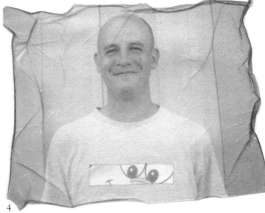

4

Projects for instant film
PEEL-APART

This project shows you three techniques that you can use with Fuji peel-apart film after you've taken your photo. Each has a unique and different effect, and they are all fun to do.

▶ HOW IT WORKS

All these techniques involve manipulating your peel-apart print in different ways, either by transferring it onto paper by rubbing, lifting the entire emulsion layer from the print, or bleaching, then scanning, your negative.

▶ WHAT YOU CAN DO

IMAGE TRANSFER
This is the technique of transferring the negative (the piece you normally throw away) of a peel-apart instant print onto paper.

After you've waited as usual for your image to develop, and you've pulled the negative and the print apart, quickly transfer the negative section onto your paper and rub hard for up to two minutes. Your image should have transferred onto the paper and created a unique, arty, textured print.

Peel apart the film and place it on the paper in very dark, preferably pitch-black conditions, as the image is still developing and you can ruin your print if there's too much light (you will just get a black smudge). Once your print is on the paper, you can switch on the lights. Keep the following points in mind.

- Bright light or sunlight (UV) can fade the transfer over time.
- Experiment with rubbing and developing times, as you may need longer or shorter than you think.
- Use a high-contrast image, as you will lose a lot of contrast in the transfer process. It needs to have a lot of punch to start with.
- Just like the development time with peel-apart film, adverse temperature will affect the final outcome.
- Different types and textures of paper can have different effects on your image.

Experiment lots with this technique, as it's a bit tricky. You may need to pull the print and negative apart much earlier than normal. It may also take a while for you to get a usable image, but do keep trying; it's well worth it.

1　Adam Bronkhorst, Polaroid 250 Land
　　Camera, Fuji FP-100C
2　Wendy Laurel, Polaroid 600 SE, Fuji FP-100C

EMULSION LIFT

This is an interesting technique that involves separating the emulsion layer from your peel-apart print by soaking it in hot and cold water. You can then place the removed image onto paper, glass, or any other surface you want, and while it's still wet, you can manipulate it as much as you like.

Cut off the white borders of your print and soak the print in a tray of very hot water (boil the kettle and wait for it to cool a bit). Soak it for a few minutes or until you see the image bubble and lift from the corners.

Transfer the print carefully into a tray of cold water. Gently manipulate the top emulsion layer, starting at the edges, until the entire image has been removed from the paper layer. Remove any gooey substance from the emulsion layer.

You can either insert the piece of paper or object that you want to transfer the image to into the water, or you can use a clear piece of acetate or Mylar to transfer the image onto your surface once out of the water. Be careful, as the emulsion layer is quite delicate.

With care, remove the emulsion layer from the cold water. You can now gently manipulate the image and work with the crinkles and texture of the emulsion until you're happy.

BLEACH THE NEGATIVE

This process uses the negative section of a peel-apart photo as well. The idea is to first let the negative dry for several hours, then use bleach to scrub the black backing off the negative, then scan the resulting image, complete with borders and imperfections.

Take a slightly underexposed image and wait for it to develop as normal, then pull the film apart and use the print as you normally would.

Let the negative part dry for several hours, then tape it face down on a piece of glass (it's important to make sure it's face down, otherwise you'll scrub the actual image off).

Dip a paper towel in bleach and clean the black backing off. You may need to scrub and scrub, as this can take a while. Take a wet paper towel and clean off the bleach, making sure none gets on the front of your taped-down image. Peel the tape off your image and let it completely dry, then scan once dry.

Experiment in your image-editing software with the colors and tones of your picture until you're happy with the result.

1

2

3

Projects for lab processing
PUSH/PULL PROCESSING | GALLERY

1

2

3

4

1	Olympus OM-1, Fuji Neopan 400 pushed to 1600	5	Olympus OM-1, Ilford Delta 3200 pulled to 800
2	Olympus OM-1, Fuji Neopan 400 pushed to 1600	6	Olympus OM-1, Ilford Delta 3200 pulled to 800
3	Olympus OM-1, Ilford Delta 3200 pulled to 800	7	Olympus OM-1, Fuji Neopan 400 pushed to 1600
4	Olympus OM-1, Fuji Neopan 400 pushed to 1600	8	Olympus OM-1, Ilford Delta 3200 pulled to 800

All photos on this spread by Adam Bronkhorst

5

6

7

8

Projects for lab processing
PUSH/PULL PROCESSING

Push or pull processing is when you deliberately shoot a film at the wrong ISO speed to make it adapt to the light conditions. You can also use it to adjust the contrast in your shots.

▶ HOW IT WORKS

Push processing is underexposing your film during shooting and compensating for this when developing. Pull processing is just the opposite—overexposing at the shooting stage and compensating for this during developing. With both, you process the film at the ISO rating at which you exposed it. For example, you may have a film that's suitable for bright, sunny days (ISO 100), but you'd like to shoot indoors or on a very overcast day. So you can shoot your ISO 100 film at ISO 400. This allows you to have the aperture and shutter speed that you need in that light.

It's also worth mentioning that you may have shot your film at the wrong speed by accident. Push/pull processing can help you with this, as your lab can correct it in the developing stage. Although you might not have done pushing/pulling on purpose, as long as you're aware of it, it may help you out when you make a mistake.

▶ WHAT IT CAN DO

With this technique, you'll lose some image quality, as you're using the film differently from how it was intended. But this might be just the effect you're looking for.

If you want gritty, contrasty images, this technique is for you. With push processing, you'll get much greater grain and contrast in your images, while losing some detail in the shadows. The increased contrast you get when pushing film can also be really useful if you're shooting on a dull, overcast day.

You can pull a film to achieve a lower-contrast image under high-contrast conditions, such as on a very sunny day. One side of a street scene may be in bright sun, and the other may be in harsh shade. This would cause a high-contrast image, so pulling your film works really well in situations like this. Be aware, though, that you may end up with a very low-contrast image.

▶ WATCH OUT FOR

Make sure the whole roll of film is exposed at the same ISO value, or you'll get uneven results. You don't want half the film exposed correctly and the other half pushed and therefore underexposed.

At the developing stage, mark clearly on your films the speed at which you shot it, and tell your lab, so they know what to do when processing.

1 Olympus OM-1, Fuji Neopan 400 pushed to 1600

2 Olympus OM-1, Fuji Neopan 400 pushed to 1600

Both photos on this page by Adam Bronkhorst

TYPES OF FILMS

Black-and-white, color negative films, and color reversal (slide) film can all be pushed or pulled. It's best to stick to black-and-white film though, as you can push these a lot further than the one or two stops recommended for color films.

Color print films are trickier. They normally have far greater latitude, so they can be incorrectly exposed by up to two stops and still produce a usable image with standard processing. When pushed, standard color print films can also develop strange and nasty color casts that can be difficult to correct (though some people do this on purpose). If you do wrongly expose your color print film by a few stops, let your lab know, as they may be able to help you out here.

3

Projects for lab processing
CROSS-PROCESSING | GALLERY

5

Projects for lab processing
CROSS-PROCESSING |
GALLERY CONTINUED

1

2

3

4

5

6

Projects for lab processing
CROSS-PROCESSING

Cross-processing is a technique by which you deliberately develop your film in the wrong type of chemicals to achieve an unusual effect in your images. The results can be unexpected, but that's half the fun.

▶ HOW IT WORKS

The most common form of cross-processing is when you shoot with a slide film (normally developed in a process called E6) and you ask the lab to develop the film in normal negative chemicals (a process called C41). This produces a variety of unpredictable effects.

Some films make lovely saturated colors with very high contrast. Others produce very green or yellow images, and some films produce images that are heavily tinted with a magenta or cyan color. These are the effects that photographers look for when cross-processing, and the aim is to create different—and more interesting—results from regular film processing.

▶ WHAT TO DO

Remember, the objective here isn't consistent or uniform images—the idea is to achieve results that look a little out of the ordinary and are also a bit of a surprise when they return from the lab. Half the fun of cross-processing is in the unexpected result.

The choice of film really does have the biggest impact on your images. The best thing to do is to experiment with film brands, types, and speeds to find what works best for you. You can load and shoot the film as usual on the camera you would regularly use. You can use your analog SLR, or for even more interesting results, try cross-processing film shot on a toy camera like the Holga, Diana, or one of the Lomo cameras.

▶ DON'T BE PUT OFF IF …

You may have some problems convincing your local lab to cross-process a film. I've had lots of different experiences. Some pro labs are more than happy to cross-process and do a fantastic job, while others will charge more than for processing the film normally. I've even had to cover up the fact that the label says it's a slide film on the side of the canister. Once your lab and technicians realize that you won't sue if you get your film back with every image a shade of pink, they're normally quite happy to help!

1 Olympus OM-1, Fuji Reala 100
2 Lomo LC-A, cross-processed, Fuji Sensia 200
 Both photos on this page by Adam Bronkhorst

TYPES OF FILMS

Here is a quick guide to some of
the different types of slide films
and the effects they can produce
when cross-processed.

FUJI
Sensia 100: magenta/red/bright green
Sensia 200: green/blue/yellow
Sensia 400: blue/green
Provia 100F: cyan
Provia 400F: green and yellow
Velvia 50: green/blue
Velvia 100: red/magenta or yellow
Velvia 100F: reds and magentas

KODAK
Kodak Elite Chrome 100: aqua/green
Kodak Elite Chrome 200: mild green/blue,
 saturates color
Kodak Elite Chrome 400: saturates color

AGFA
AgfaPhoto Precisa CT 100: gorgeous blues,
 strong contrast and saturation

LOMOGRAPHY
X-Pro Slide 100: intensifies color
X-Pro Slide 200: strong contrast
 and saturation

Projects for home processing
BLACK-AND-WHITE | GALLERY

1

1 Adam Bronkhorst, Lomo LC-A, Fuji Neopan 400
2 Adam Bronkhorst, Lomo LC-A, Fuji Neopan 400
3 Nathan Pask, Canon Canonet GIII QL17, Ilford Delta 400
4 Adam Bronkhorst, Lomo LC-A, Fuji Neopan 400
5 Adam Bronkhorst, Lomo LC-A, Fuji Neopan 400

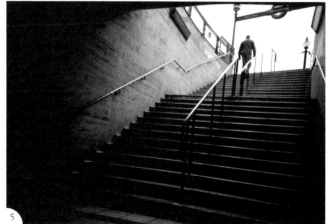

Projects for home processing
BLACK-AND-WHITE

This is a really simple introduction to home developing. All you need is a bathroom, some equipment, and you can get started. You'll save a fortune in lab-processing costs, and it's actually great fun.

▶ HOW IT WORKS

The process consists of three stages: developing, stopping, and fixing. Developer creates a chemical reaction with the areas of film that have been exposed; stopper halts this process, washing away any remaining chemicals; and fixer literally fixes the image onto your negative.

Start with 35mm film, as that is the easiest. The timing for each stage depends on your film type, the chemicals you use, and their temperature. Follow the manufacturer's instructions, and take a look at the fantastic Massive Dev Chart website for more guidance (www.digitaltruth.com). They also have an iPhone App you can use for timings.

Although the chemicals you'll use aren't too hazardous, you should wear disposable vinyl gloves and eye goggles. Check with your local water company as to which products you can safely pour down the sink, and store all chemicals away from children and animals.

▶ WHAT TO DO

PREPARE
If you're working in your bathroom, run the shower for a few minutes before you start. The steam will clear a lot of dust in the air, so you'll get better results with your negatives when they dry. Get your film, chemicals, and equipment all ready.

LOAD THE DEVELOPING TANK
Place your film canister, developing tank, scissors, and a bottle opener inside your lightproof bag (or if you're in a lighttight room, lay out everything where you'll be able to find it in the dark.) Use the bottle opener to flip off the bottom of the film canister, then carefully pull your film out of the canister, and load it onto your spool. Sometimes cutting the start of the film helps here.

The end of the film will be taped to a plastic reel inside the canister. Cut it from the reel, and remove all the tape from the film. Place the loaded spool into the tank, and close the lid. Once your film is safely inside your lighttight tank, you can remove it from the bag and switch the lights on.

WASHING
Hold the tank under a faucet and fill it with water. Shake it from side to side for a few seconds, and then pour away the water. This keeps the film moist, which ensures you get the best results when developing.

DEVELOPING
Following the instructions and timing guidelines, add developer to the tank. Leave it for the amount of time indicated by the manufacturer, then shake the tank as recommended by the manufacturer. Empty out the developer, and wash your film again to rinse off the chemicals.

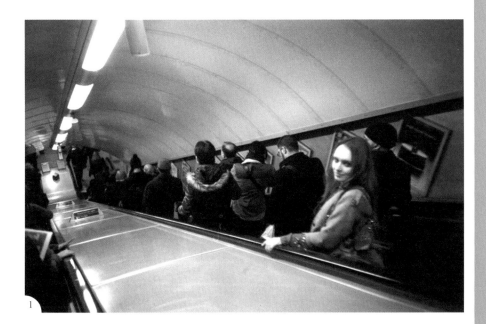

1

WHAT YOU'LL NEED

- lightproof film-changing bag
- developing tank with spools
- bottle opener
- scissors
- developer
- stopper
- fixer
- wetting agent
- measuring jugs for your developer, stopper, and fixer
- timer
- string or clothesline and bulldog clips or clothespins

STOPPING

Now it's time to add stopper to the tank. Leave it for the required time, and then shake it. You can substitute stopper for a really good wash (for about 7 minutes) in water. But if you use it, remember to wash the film once you're finished.

FIXING

Finally, pour fixer into the tank, leave it, and shake it as per the instructions and timing guidelines. Once all three stages have been completed, wash your film, again using a wetting agent—this ensures there'll be no water marks on your negatives.

DRYING

Hang your negatives up to dry above your bath or shower, weighting them down with clothespins or some bulldog clips to stop them from curling up. (Watch out, though, as some metals can rust and leave residues on your films.) Once your negatives are totally dry, you can cut them up and scan them.

Projects for home processing
COLOR | GALLERY

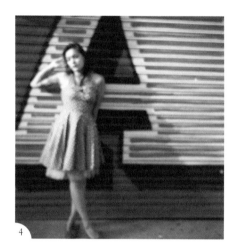

4

5

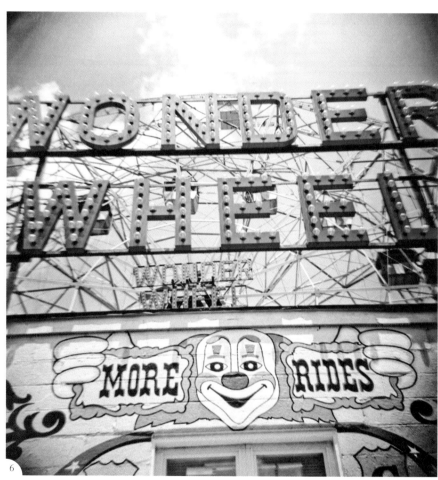

6

Projects for home processing
COLOR

If you've mastered black-and-white developing, take the next step and try developing color film at home. It follows a very similar process, but you need to keep a watchful eye on temperatures.

▶ HOW IT WORKS

Developing color (C41) film at home can be a lot easier than black-and-white processing (see page 042) The timings are usually the same, regardless of the type and speed of film you're using, and if you have the equipment for developing black-and-white film, you should be able to use it for color.

But be aware that the chemicals are a lot more hazardous than with black-and-white processing, and they're more expensive. And one of the biggest challenges is that you need to be more precise about the temperature of your chemicals.

▶ WHAT TO DO

This process is very similar to black-and-white developing. First, there's a developing stage. Then, instead of stopping and fixing stages, you have a bleaching and fixing stage in one. This is also known as a "blix" stage. You then rinse the film, adding a final quick stage to stabilize the film, and you're done. Look for more detailed information online.

TEMPERATURE

Some developers need to be kept at 100°F (38°C), with a tolerance of less than 1°. If you don't get the temperature correct, you'll get color shifts, so if you're not after 100 percent accuracy, it's fine. You should still get very usable images.

Try filling the sink with very hot water and standing your chemicals in it. I've heard of someone who used a fish-tank heater. But it's quite difficult to find a fish-tank heater that heats up to 100°F, as most fish don't ever get that hot (unless they're just about to be eaten).

EQUIPMENT

If you have all the equipment to develop black-and-white film (see page 043), you can use some of this for color film, like the developing tank, reel, measuring jugs, and so on. But it's advisable to use separate chemicals for color and black-and-white developing. You'll also need a thermometer.

If you're serious about color developing at home, look at some of the great processing machines available. You should be able to use these to develop color, black-and-white, and paper as well.

The advantage of these machines is that they automatically regulate the temperature and agitate your tank with the film in it for a set time and frequency. This ensures you get far more consistent results with your processing. Search online for secondhand models. The JOBO CPE-2 Plus Processor comes highly recommended.

But if you're just going to be developing the odd roll of film here and there, you probably don't need to invest in expensive equipment like this. Just be aware that if you're not doing too much developing, the chemicals can go bad if stored for too long.

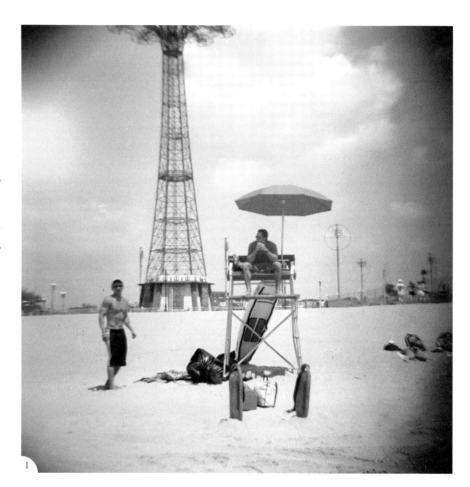

1

Projects for home processing
UNUSUAL CHEMICALS | GALLERY

1

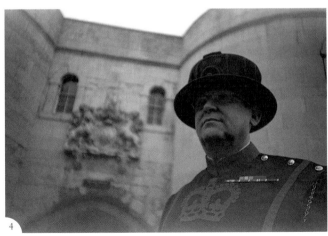

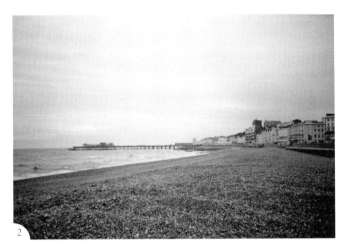

Don't want to use lots of chemicals to develop your film? Try using instant coffee, washing soda, and white vinegar for the ultimate lo-fi developing experience. Raid your kitchen cupboard, and experiment.

▶ HOW IT WORKS

It's possible to concoct developer, stopper, and fixer from products you'll find in any supermarket. Will they produce results as good as top-brand chemicals? Absolutely not, and you'll need to experiment to find the formula that works for you.

Tea, red wine, powdered vitamin C, cola, and human urine can all work really well. The fixer described here, using coffee and other common household products, is also known as caffenol. Be aware that results can be unpredictable—try it with a test roll of film to see how it goes before you hit your reel of prize-winning photos. Unfortunately, you don't get a pleasant smell of coffee as you work—you get the awful aroma of burnt coffee. Don't panic; that's quite normal.

One piece of kit you'll definitely need is a proper developing tank, as you can't really go lo-fi on that. For more on the process with traditional chemicals, and other useful equipment, see pages 040–047.

▶ WHAT TO DO

DEVELOPING

The two essential components of a photographic developer are a developing agent and an activator. Use instant coffee granules, as the caffeine in them will act as the developing agent. For the activator, use washing soda (sodium carbonate)—be aware that baking soda won't work. Coffee has been known to stain negatives with a sepia tone, but this isn't always a guaranteed outcome. Just relax and enjoy experimenting.

To develop one roll of 35mm film, dissolve 5 teaspoons of instant coffee in about 10 fl oz (300ml) water, followed by 2 teaspoons of washing soda. Only stir in the washing soda when the coffee has dissolved. Then develop your film for about 25 minutes, agitating every 30 seconds. This is a very simple formula, and you'll have to experiment a lot to find the one that suits your type of film.

STOPPING AND FIXING

You don't have to use a specialist chemical to stop your film development; lots of photographers just use a long, thorough rinse in water (about 7 minutes). If you can't wait that long, a solution of water and white household vinegar can work well. The solution should be about 1 percent acid. Household vinegar is about 5 percent acid, so use about four times as much water to vinegar to get the solution right.

As for the fixer, you can use saltwater; seawater was used in the past. However, saltwater makes the process very slow and inefficient compared with modern fixing solutions. It's also possible to use sodium thiosulfate crystals, which are used to control excess chlorine in swimming pools. These should be available from pool-supply companies.

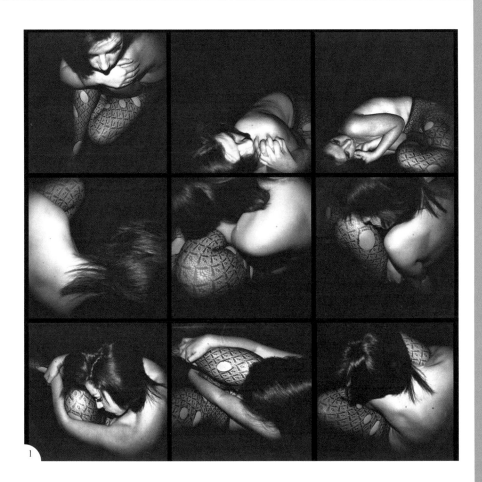

1

MAKING IT EASIER

If you'd like to give this a go, but it all sounds too much, you can always just use the alternative coffee-developer method and finish up with traditional chemicals to stop and fix your film.

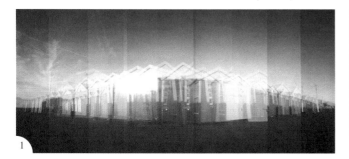

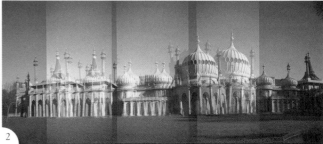

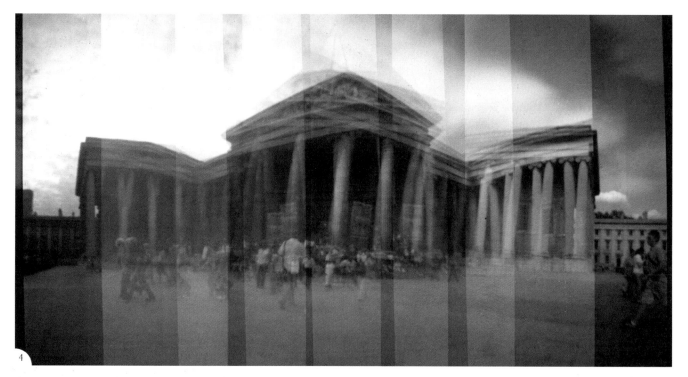

4

5

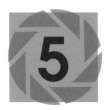

5 MICROCLICKS |
GALLERY CONTINUED

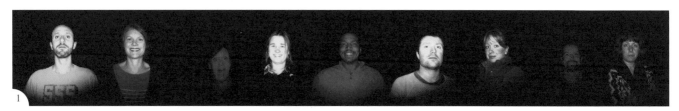

1

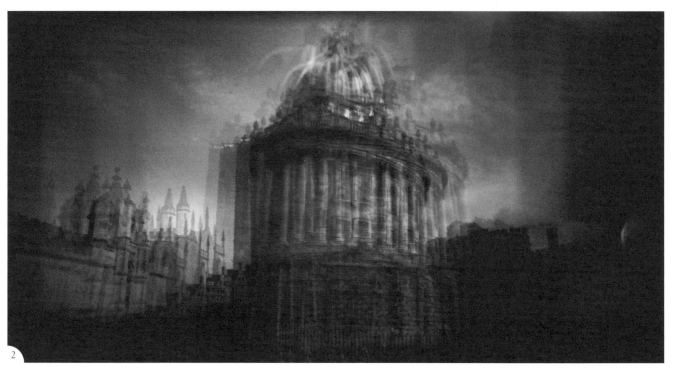

2

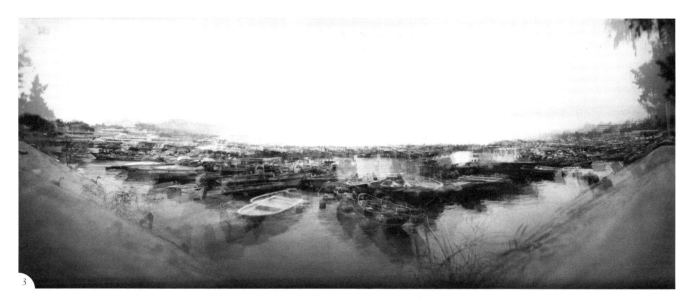

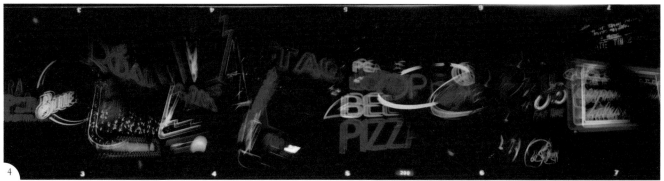

Projects for exposure
MICROCLICKS

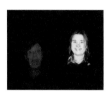

This simple technique shows you how to create a unique multiple-exposure panoramic image over a section of your film with your Holga or Diana, with crucial tips on how to handle developing.

▶ HOW IT WORKS

To use the microclicks technique, you take multiple exposures and only wind the film on a little bit between shots, therefore creating an overlapping image of your vista. It works well with Holga or Diana cameras, because with them, you have the ability to wind the film on as much or as little as you like. (For another project featuring panoramic images, see pages 102–107.)

▶ WHAT TO DO

Pick a subject that'll work well in a panoramic shot. Buildings and structures are really good for this. Line up your camera, framing the left-hand side of your subject. Click the shutter, winding on your camera carefully by four or five clicks. Then move your camera a little to the right to reframe the subject. Try to overlap your frames by one-third. Click the shutter, and wind on your camera four or five clicks. You should be getting the idea by now.

Continue this until you've shot your entire subject. Then wind on your camera by 32 clicks. This is the amount that you should normally wind on between shots. That way, you have a nice clean end to your frame.

▶ WHEN SHOOTING

When you're moving a little bit between each shot, it can make life easier to fix your camera to a tripod. That way, you get a measured amount of movement, and your camera will always stay level and in the right place. That said, part of the appeal of these shots is the kind of chaos they achieve. So don't always be hung up on achieving the perfect shot. A bit of unpredictability can make an image.

Another technique that works well is to shoot lots of people along the film. Shoot someone, wind on a bit so the next person doesn't overlap, then shoot someone else. So instead of winding on 4 or 5 clicks, make it 10 or 15. In fact, have fun; make it 20 or make it 8. Find out what works best for you.

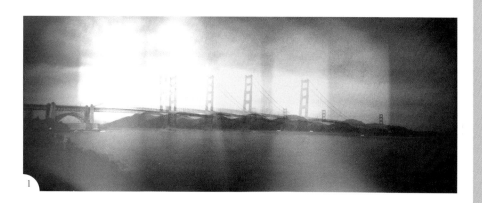

1

DEVELOPING AND SCANNING

Let the lab that's developing your film know what you've been doing. Your negative for this image will be longer than usual. If you're using 120 film, your normal negative will probably be square and of a 6 × 6 format. Your microclick image will often be three to four frames, and that can be 7 to 9½in (18 to 24cm) long.

There's nothing stopping you from shooting the whole length of your film, and for a 120 film, that can mean a negative of up to 33in (84cm) long. That's why it's crucial to let your lab know what you've been up to. They may not realize your intention, and cut your negative to the standard 6 × 6 format, thus ruining your image.

Your lab may well have a machine that scans negatives, but this probably won't cope with negatives longer than the standard format. So you'll have to scan the image yourself for the best result.

▶ WATCH OUT FOR …

Develop your own technique. When you're shooting people like this, try to shoot them against the same background, so that you get one long image with lots of people in it. It works best with a dark background. You'll expose some bits of film twice, but with a black or very dark background, you won't see the overlap—even in pitch darkness with flash.

You're going to be exposing the same portion of film over and over, so follow these tips to avoid overexposure:

- Always use the lowest ISO film possible.
- Shoot on an overcast day.
- Use a neutral density (ND) filter, which is a bit like sunglasses for your lens—it reduces the amount of light entering your lens.
- Use redscale film (see pages 016–019). It's very hard to overexpose this film, and therefore it's perfect for microclicks.

Projects for exposure
MULTIPLE EXPOSURE | GALLERY

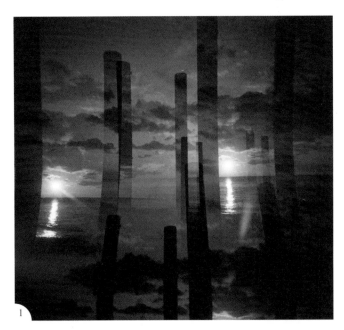

1

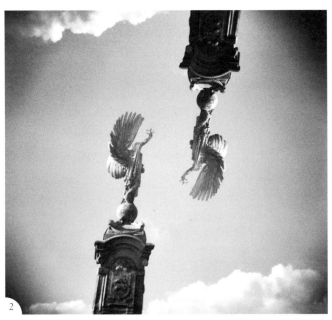

2

3

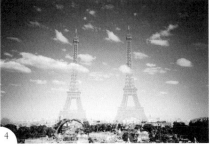

4

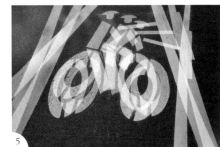

5

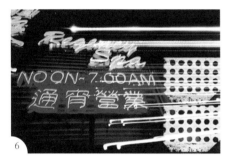

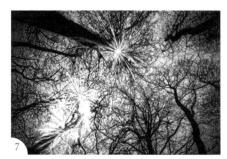

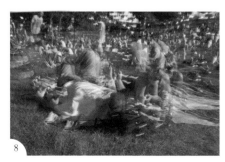

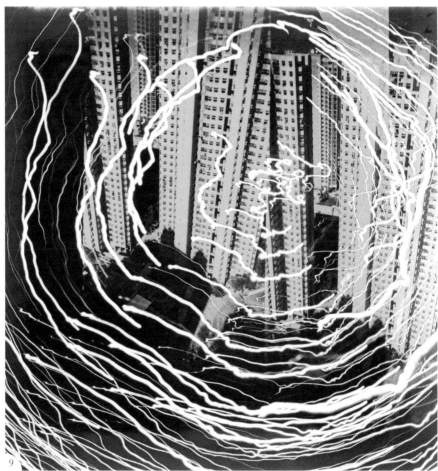

Projects for exposure
MULTIPLE EXPOSURE

With multiple exposure, two or more images are shot onto the same section of film, creating a fantastic layered effect. It can sometimes happen by accident, but this project shows how you can do it by design.

▶ HOW IT WORKS

First off, check your camera to see if it's able to take multiple exposures. Some cameras won't allow you to take another shot until the film has been wound on. On most Holga and Diana cameras, you can take as many shots as you want, as these cameras have fully manual wind-on functions. With these, you choose when to wind the film on, rather than the camera choosing for you. The Lomo LC-A+ and some other cameras have a special button that allows you to shoot another frame without having to wind the film on.

▶ WHAT YOU CAN DO

There's a whole range of exciting options for multiple-exposure projects. You can shoot the same subject two or more times, placing it in different positions in the frame. This creates a dramatic graphic image.

Try shooting a bit of texture, like grass or wallpaper or some other pattern that grabs your attention. Then shoot your subject.

Shoot the same person a few times, but looking in different directions, to get a multiple-exposure portrait.

Shoot a roll of film normally, but instead of rewinding it totally, leave the little leader of film sticking out. Then, give the film to another photographer to shoot over what you've done. You'll have some unique images that are a combination of two people's efforts. I've heard of some photographers sending their film (once shot) to Internet buddies on the other side of the world.

▶ WHEN SHOOTING

One challenge with this technique is that as you're exposing the same bit of film a number of times, your image may become overexposed. As a rule of thumb, if you're exposing your film twice, underexpose each shot by one stop. If you're going for four exposures, underexpose each image by two stops, and so on.

Dull days and low-light situations are great for multiple imaging, because you can use a film with an ISO that's too low for an overcast day. When it's exposed a number of times, you'll get a good result.

▶ WATCH OUT FOR …

Multiple-exposure images can look very cluttered and abstract, as there's more information in the picture than usual. Personally, I like my multiple exposures to be quite simple, and I only choose multiple exposure when it really suits the subject.

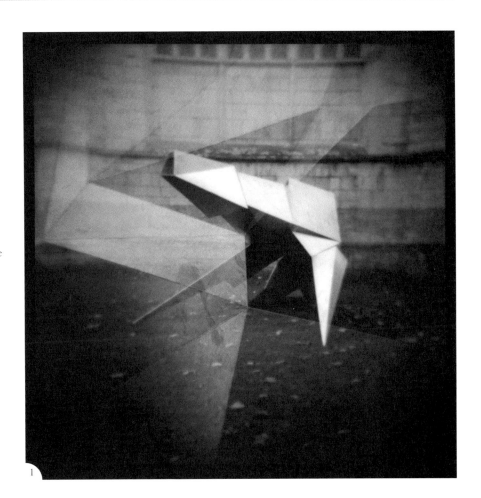

1

LONG EXPOSURE | GALLERY

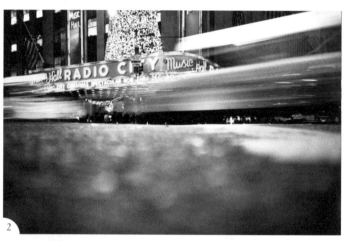

2

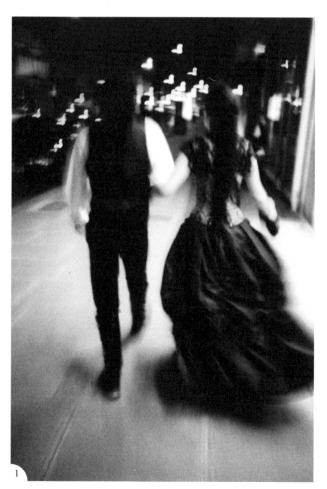

1

3

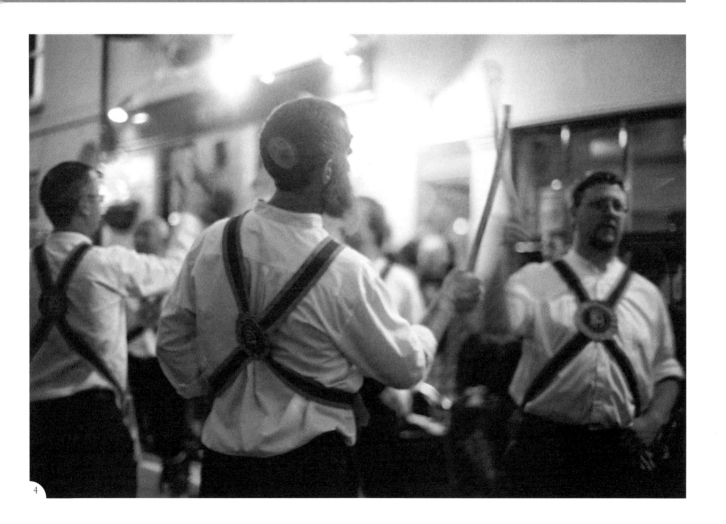

4

5 LONG EXPOSURE | GALLERY CONTINUED

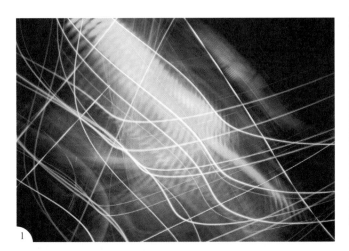

1

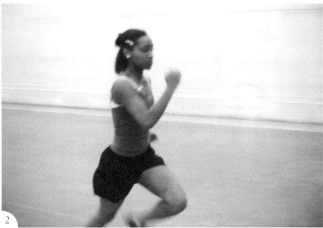

2

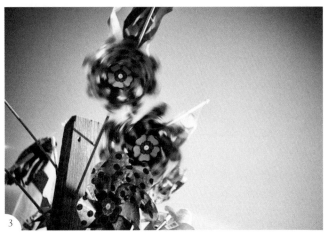

3

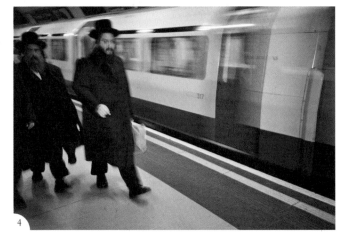

4

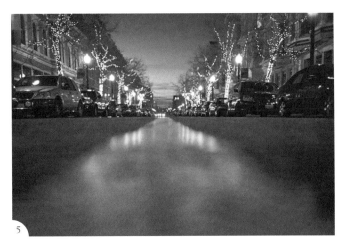

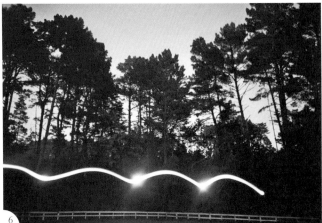

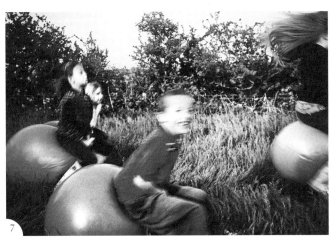

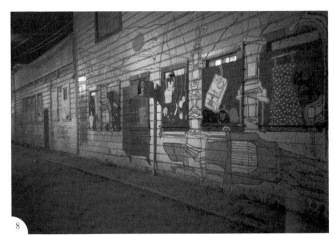

Projects for exposure
LONG EXPOSURE

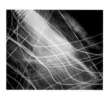

By exposing your film for longer than usual, you can discover a whole new world of blurred movement and light trails—a dazzling array of effects that are usually invisible to the human eye.

▶ HOW IT WORKS

Long exposure is opening your camera shutter for longer than usual so that more light hits the film. For this project, I'm defining a long-exposure image as one that's been taken with a shutter speed slower than 1/60 of a second. This is generally viewed as the slowest shutter speed you can hold a camera at without getting blurred pictures from camera shake.

When you shoot slower than this, there's a good chance you'll capture movement from a subject in motion. For example, if you have the camera on a steady surface and take a picture of a moving car at 1/30 of a second, you'll probably get some blurred movement in the image. (For a project on really long exposure, see pages 112–115.)

▶ WHAT TO DO

You'll need a tripod or sturdy surface to support your camera while the shutter is open. You want movement and blur, but only from your subject—not a totally blurred image caused by camera shake.

Your camera needs to have a function that allows you to keep the shutter open. Some Holgas are good for this, as you can switch the camera to "bulb" mode and hold the shutter open for longer. The Lomo LC-A, too, keeps the shutter open for as long as it needs to in order to capture the image. Of course, an SLR with a cable release and the ability to shoot on slower shutter speeds will also work well.

Use a slower film, like ISO 100. It lets less light into the camera and allows you to keep the shutter open longer.

Long exposure works best on duller days or at night. On a sunny day, you'll just get an overexposed image, as too much light will reach the film. It's possible to get neutral density filters for your lens that can block a few stops of light to prevent this. But generally, it's easier to shoot in less light. I know some people who take long-exposure shots at night, with shutter speeds way over 15 minutes long. This allows so much light into the shot that it doesn't look like nighttime any more.

▶ WHEN SHOOTING

Think about capturing movement. What can you achieve with long exposure that a normal exposure wouldn't? Anything that moves can give interesting results.

Try shooting moving traffic, fireworks, sparklers, fairgrounds at night, or flashing neon signs.

Shots of people can work really well. If you move the camera with the subject, your subject will be frozen, and your background will be blurred.

If you don't mind everything in the image being blurred, try moving the camera with your hands or spinning it on the tripod.

Try light painting. Use lights (flashlights are always good) and movement to paint a long-exposure image. Try moving the camera, or try moving the light source. Either way, you'll capture something the naked eye won't normally see.

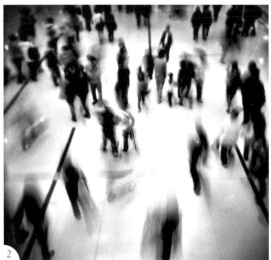

1

2

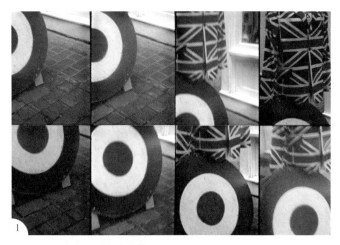

3

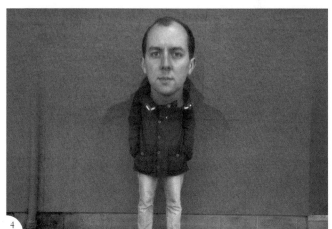

4

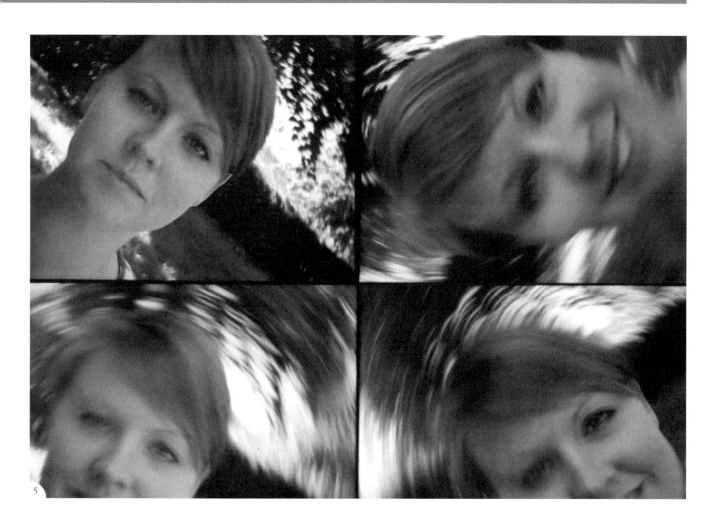

5

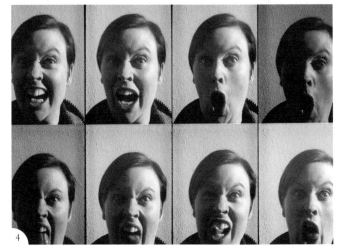

1 Beth Wilson, SuperSampler, AgfaPhoto Precisa CT 100
2 Adam Bronkhorst, SuperSampler, Fuji Superia 400
3 Adam Bronkhorst, Split-Cam, Kodak Gold 400
4 Adam Bronkhorst, Oktomat, unbranded film

5 Adam Bronkhorst, Oktomat, Kodak Gold 400
6 Adam Bronkhorst, Pop9, Kodak Gold 400
7 Adam Bronkhorst, Split-Cam, Kodak Gold 400
8 Adam Bronkhorst, Oktomat, Kodak Gold 400

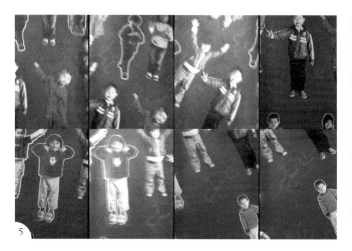

5

6

7

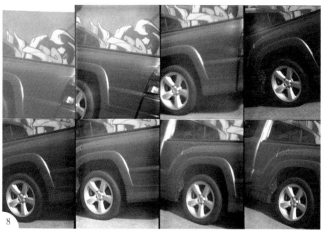

8

Projects for exposure
MULTILENS

This project explains how, using any of the cameras listed below, you can tell stories, show movement, and get creative with pattern in your photography.

▶ HOW IT WORKS

SUPERSAMPLER
The SuperSampler takes four sequential shots on a single 35mm negative, in vertical or horizontal panoramic format. There are two shutter-speed options. At 0.2 seconds' exposure, you get an almost instant multi-image. At 2 seconds, you can capture more movement. This is my favorite multilens camera, because of the great images it produces.

OKTOMAT
The Oktomat takes eight images in succession. Take a look at the lenses and you'll see how your frame is divided: four images in the top half and four in the bottom half. The camera shoots eight frames over 2.5 seconds—that's a long time in photography terms. This means you can really go to town with your image and create a story.

ACTIONSAMPLER
The ActionSampler also takes four sequential images over one frame of film. Here, the print is divided into quarters, with two images on top and two on the bottom. The camera has a fixed aperture and only one shutter-speed option. So when you press the shutter, four shots are taken over 0.66 seconds.

SPLIT-CAM
The Split-Cam isn't technically a multilens camera, but it takes a multiple image on one negative by masking off either the top or bottom half of the frame.

POP[9]
The Pop[9] doesn't shoot images in sequence— its nine lenses take nine simultaneous shots. What this means is that repetition is key. Your picture will be a beautiful pop art–style print. With the cameras above, it's best to think about movement. With the Pop[9], it's best to think about pattern. It has two great features to feed your creativity. One is the ability to focus as close as 31in (80cm) to your subject, meaning you can really zoom in on eye-catching detail. The other is a built-in flash, so you don't have to save your Pop[9] adventures for daytime. Get out at night.

1

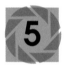

Projects for exposure
MULTILENS CONTINUED

5

▶ WHAT YOU CAN DO

SUPERSAMPLER AND OKTOMAT
With the SuperSampler or Oktomat, you're shooting over 2 seconds or more, so go to town with the time you've got. Capture movement, or change the camera's position. Basically, you've got longer to be creative!

Get someone to jump about or dance in front of the camera when you're taking your shot. You'll get a great sense of movement. If your subject is fixed, like a building, you can capture more than one side of it. But you'll have to be quick!

Look for different details on the same subject (like a phone booth) that you can feature in the same sequence.

Twisting the camera in your hand works well for graphic images such as text or road markings.

You'll be surprised how far you can move during the exposure time. Run up to someone, move in close, and make them grow over the image sequence. Or move further away and make them shrink.

Think about your frames as a storyboard and use them to show where you are, what you're doing, and who you're with. You can animate your shots at a later date to make a mini film.

ACTIONSAMPLER
With the ActionSampler, you've only got 0.66 seconds. Try shooting a moving subject, or if the subject's fixed, it's you that has to move—fast.

SPLIT-CAM
With the Split-Cam, take a shot of the bottom half of your subject, say a friend's head and shoulders, then move in closer and line up their head in the top half of the frame and shoot. You'll now have a photo of your friend with a very large head.

POP9
Use the Pop9 to focus on interesting details of faces or objects to create gorgeous patterns.

1 SuperSampler, Fuji Superia 400
2 SuperSampler, Kodak Gold 400
Both photos on this page by Adam Bronkhorst

FILM FOR MULTILENS CAMERAS

With the models here, it's best to use a high ISO-rated film, as they're not as sensitive to light as other cameras. If you use a lower-rated film, such as ISO 100, you may find your images are underexposed, dull, and flat. I wouldn't put anything lower than ISO 400 film into these cameras, even on a bright, sunny day.

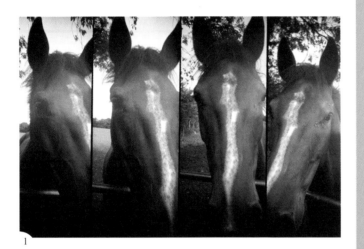

1

2

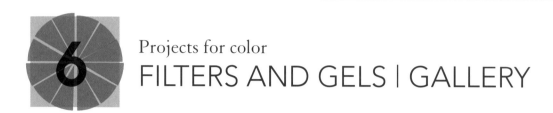

1

1 Olympus OM-1, Fuji Reala 100
2 SuperSampler, Kodak Gold 400
3 Olympus OM-1, Kodak Ektar 100, slight warming gel
4 Olympus OM-1, Kodak Ektar 100
5 Olympus OM-1, Fuji Reala 100
All photos on this spread by Adam Bronkhorst

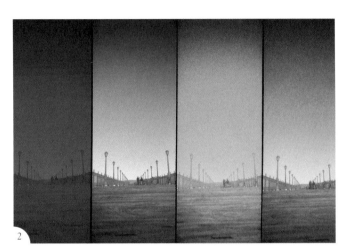

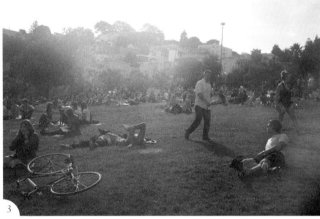

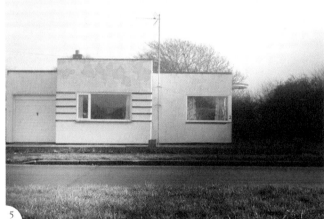

6 FILTERS AND GELS

Turn the dullest photos into a spectrum of the spectacular with colored gels and filters. Go DIY, or try a full-on dedicated filter system—how you add color to your images is up to you.

▶ HOW IT WORKS

If you want to color your images the analog way, you've got three options. Gels are basically colored pieces of transparent plastic. You can buy them from some photography or art stores or anywhere that sells or hires disco equipment or theater lights. But use your imagination, too. Look around. That pink plastic folder, those candy wrappers … in fact, anything that's colored and see-through can be used as a gel—even sunglasses.

You can also try dedicated filters that fit your camera lens. Many of the big names in the toy camera market sell readymade filter sets. A third option is to try something like the Cokin filter system, which fits any type of camera. You fix a filter holder onto your lens, and select whichever filters you want. There's a huge range of dedicated filters with different effects, plus you can make your own colored filters to fit the holder. To see what happens when you use colored gels and filters with flash, see pages 080–083.

▶ WHAT YOU CAN DO

The advantage of using gels and filters is that you don't have to keep them on for the entire roll of film. You can use a different filter for every shot. Why not use slide film and make a transparency rainbow?

Make your own filters. Cut a hole in some black card (any shape you like). Stick some colored gels over the hole. Then use a Cokin filter holder to secure the filters over your lens.

Try making up a national flag with colored gels and shooting through that.

Use two colors split down the middle. Or divide your lens up any way you like. The wilder, the better.

Use a colored gel, but with a big or small hole cut in the middle. That way you get a lovely soft color vignetting in your shots, while the middle of your image looks normal.

If you've got a SuperSampler or any camera that shoots through multiple lenses, stick a different-colored gel on each lens and see what happens.

Smear creams, gels, oils, or Vaseline, or even secure pantyhose over your lens to create interesting effects. Use a little common sense here, and make sure that if you do apply anything that could damage your lens, you do this to a UV filter and not the lens itself.

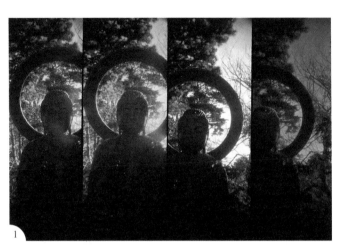

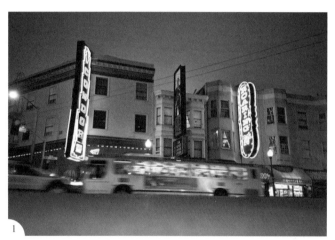

1

2

3

4

5

Projects for color
FLASH WITH GELS

This technique uses a colored bit of plastic or gel in front of the flash. With it, you can turn your flash from the standard white to any color you want, and the effect can be as subtle or as striking as you like.

▶ HOW IT WORKS

There are some specially designed colored flashguns available, including the Colorsplash Flash sold by the Lomographic Society, designed mainly for use with the Lomo LC-A (or LC-A+) camera. You don't need to have a Colorsplash Flash though, as you can put a gel in front of any flash. Some Holga cameras have a built-in flash with different-colored gels. I often use colored gels on my flashes even with digital cameras.

The easiest place to find colored gels is anywhere that sells specialist disco lighting equipment. Most stores sell them by the sheet, or you can buy a sample booklet that has lots of different colors. A little Scotch Tape will secure the gel to your flash. But don't limit yourself to specialist stores. I've heard of people using candy wrappers, beer bottles, and even tinted sunglasses. In fact, you can use anything that has a bit of color, is transparent, and can be held in front of the flash.

▶ WHAT YOU CAN DO

By changing the color of your flash, you've just opened yourself up to a whole host of creative possibilities.

Try putting a colored gel on your flash and shooting in daylight. Turn your subject red or pink against a blue sky. Shoot the same shot four times with a different-colored flash for each shot.

Shoot at night against a colored background that's far enough away from your flash so the light from it won't hit the background. This will make your foreground subject stand out in an unusual way.

If you are shooting indoors, you can change the color of the whole scene with gels, or you can use colored flash to add atmosphere to an image. Try taking the flash off your camera and use the colored gel as an accent color.

A straw-colored gel just gives a slight golden color to the flash and almost gives people a light suntan. I use it mainly for fill-in flash during bright days but also when I need to shoot with flash in darker situations. It's a subtle use of gels and colored flash, but there's no law that says all your projects and techniques need to be loud and bold.

1 Olympus mju-II, Fuji Superia 400, warming gel on flash
2 Lomo LC-A, Kodak Portra 400VC
 Both photos on this page by Adam Bronkhorst

▶ WATCH OUT FOR ...

If you're going to use a colored gel in front
of your flash, be aware that this will block
the flash a bit and take up some of its power.
A dark-blue gel will eat up a lot more power
than a light straw-colored gel, and, as a result,
the flash won't be as powerful or able to
reach as far.

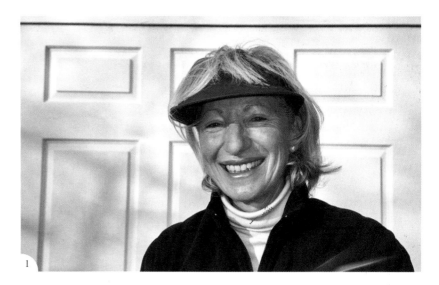

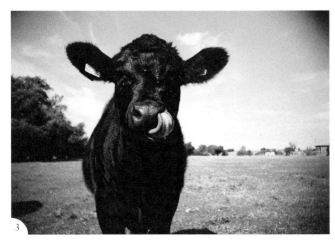

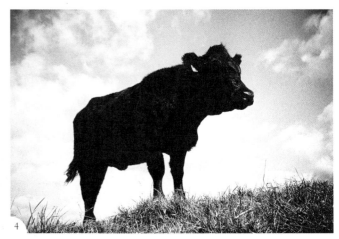

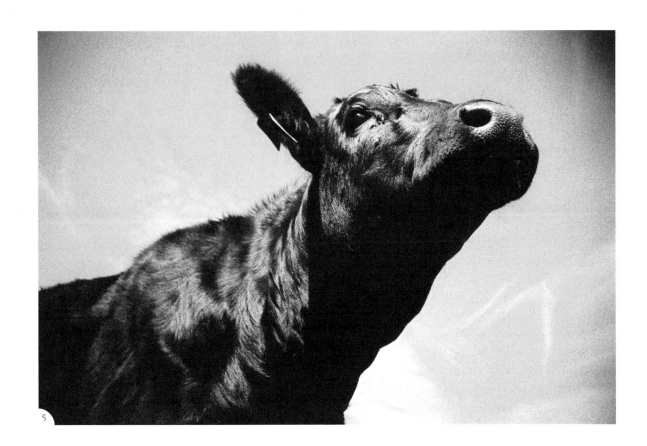

1

2

3

4

1	Lomo LC-A, Fuji Neopan 400	5	Olympus mju-II, Fuji Superia 400
2	Olympus XA, AgfaPhoto Precisa CT 100	6	Olympus mju-II, Fuji Superia 400
3	Olympus OM-1, Fuji Sensia 200	7	Olympus mju-II, Fuji Superia 400
4	Fisheye Camera, Fuji Superia	8	Olympus mju-II, Fuji Superia 400

All photos on this spread by Adam Bronkhorst

Projects for specific subjects
7 THEMES

This project shows you how, with a particular theme, you can build a portfolio of really interesting and varied images fast. There are no strict rules; just pick whatever interests you, and get shooting!

▶ HOW IT WORKS

This is all about finding a theme and taking it as far as you want to go. You need to find a topic you can really explore. So take a photo of something that interests you—let's say vintage cameras—and keep on doing it until you've run out of ideas. One photo of an old camera doesn't really say anything, but a series of shots of different cameras begins to look more interesting, as you can compare and contrast your pictures. A story, pattern, or narrative begins to emerge. Well, that's the idea, anyway!

▶ WHAT YOU CAN DO

Personally, I have a few things that I like to shoot. The first shot on a new roll of film may often have been exposed to a bit of light. Instead of winding the camera on so I have a good frame to start shooting, I take a picture of myself, holding the camera at arm's length.

I like vintage cars, so when I see them I try to shoot aspects of them, and I live by the sea and have a thing for seagulls, so I shoot them when I see them doing something interesting.

I also went through a stage of photographing my empty plate when I'd finished eating in a restaurant. And I like photographing lost gloves. I live in England, and it can be quite cold in the winter, but I'm always amazed at the amount of abandoned single gloves you see lying around.

Being a film fan, I like to shoot other people's film cameras. Not just the camera, but a detail of the photographer holding the camera.

By the time I've loaded the camera, taken my first shot, gone for a walk, seen a vintage car, spotted a seagull doing something interesting, found a lost glove, had some food, and met someone with an unusual film camera, there really isn't much film left for other things.

Here are some more examples from friends who shoot themed projects as well:

- interesting-looking breakfasts
- streetlights that have been left on during the day
- chefs smoking outside on their breaks
- tattooed hands
- pictures of cows
- photos of 100 strangers

The list goes on and on and on...

1	Olympus OM-1, Fuji Reala 100	3	Olympus OM-1, Fuji Sensia 200
2	Olympus mju-II, Fuji Pro 800Z	4	Olympus mju-II, Fuji Reala 100

All photos on this page by Adam Bronkhorst

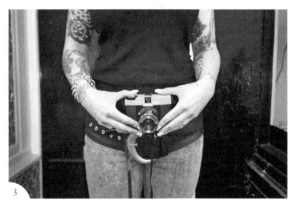

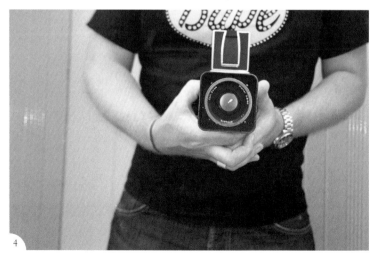

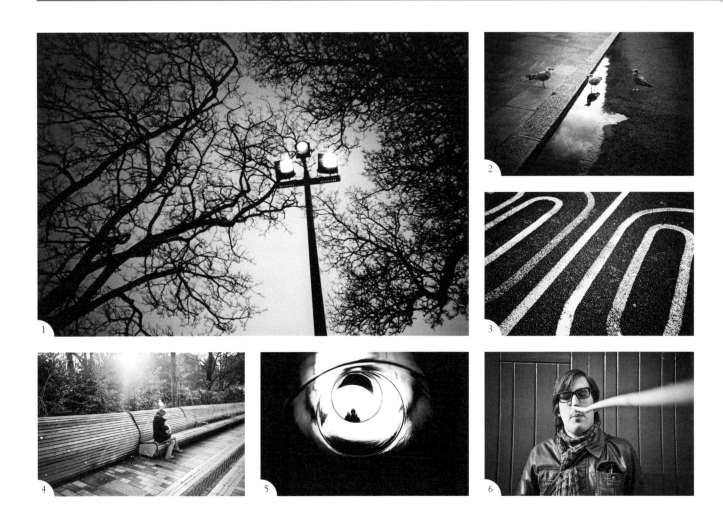

7

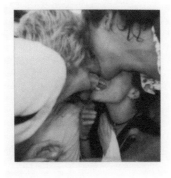

8

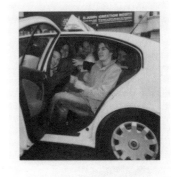

9

10

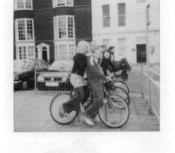

11

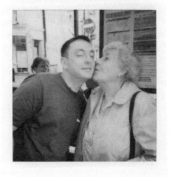

12

Projects for specific subjects
URBAN GAMES

This project is all about turning your photography into a game. Whether you're alone or with friends, set some fun challenges using the city as a backdrop. The results can be really creative.

▶ HOW IT WORKS

I'm not sure this is a recognized discipline of photography, but it's worth trying, as it can be very entertaining. The idea is to have some fun with your photography and play a game shooting specific subjects. It's easier to complete these tasks in towns and cities, so I've called this project urban games.

The idea of urban games is for them to be as entertaining as possible. You shouldn't make it too hard for people; make sure anyone participating enjoys themselves. Include some items that are hard to find, but add some very easy things as well. Make sure you all meet up at the end of the day and compare pictures and stories.

▶ WHAT YOU CAN DO

SCAVENGER HUNT
On my thirtieth birthday, I organized a big drunken scavenger hunt for a bunch of my friends. We arranged ourselves into six groups of six. Each group had an instant camera and a long list of slightly risqué or amusing tasks to complete. The group that had evidence of completing the most tasks won. Examples of the tasks include:

- drink a colored shot
- fit the whole team in a taxi
- fit the whole team in a phone booth
- streak
- get the whole team on bikes
- get a kiss from a stranger or an old lady

MONOPOLY
This one will only work in cities that have Monopoly games based on them, but the idea can be adapted to other games or topics. Make a list of all the places on the Monopoly board that you think you can photograph.

I once spent a day traveling around Paris with a good friend, shooting as many of the tourist attractions as we could, as quickly as possible. So we'd go to the nearest station to the Eiffel Tower, get out, take a photo, go back to the station, and move on to the next photo opportunity. You could make it really tough and try to travel the board in the correct order. Or shoot all the place names you can.

I've also found a board game, Photo-opoly, that follows the same rules as Monopoly but the board is totally adaptable, so you use your photos for the real estate spots. It's Monopoly, but with *your* photos.

1 Lomo LC-A, AgfaPhoto Precisa CT 100
2 Lomo LC-A, AgfaPhoto Precisa CT 100
Both photos on this page by Adam Bronkhorst

SHOT LIST

A similar game is to write a list of items to find and shoot around town. Write a list of 100 items and see how many you can cross off in a few hours. You could try to pick a theme to cover. For example, shoot the whole alphabet in order, people with hats, the color red, and so on.

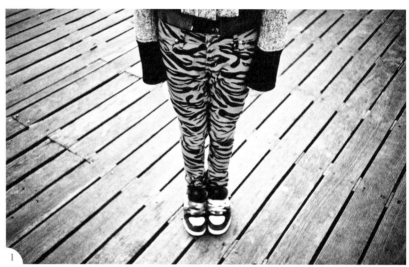

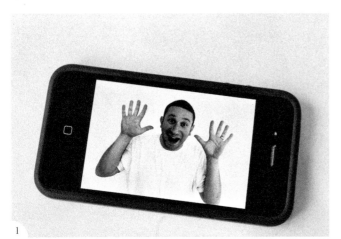

1

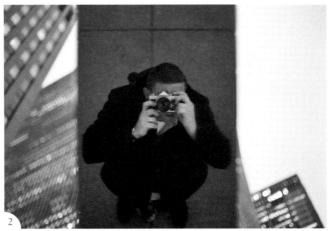

2

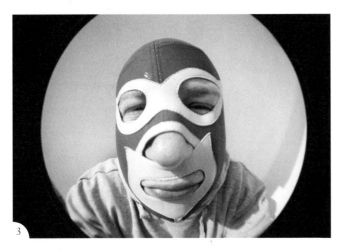

3

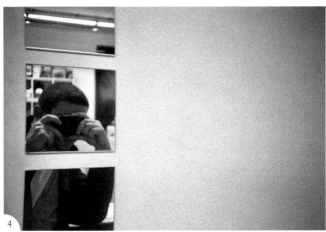

4

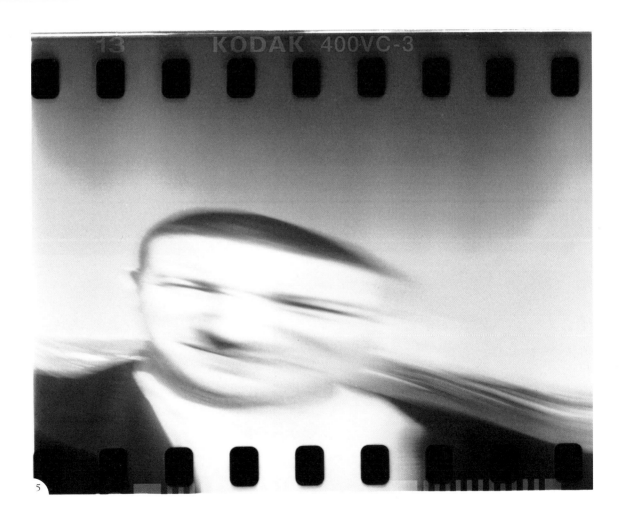

5

Projects for specific subjects
SELF-PORTRAITS | GALLERY CONTINUED

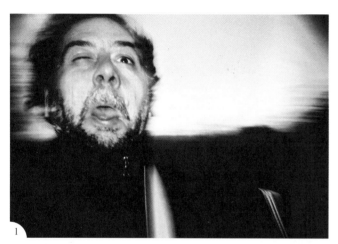

1

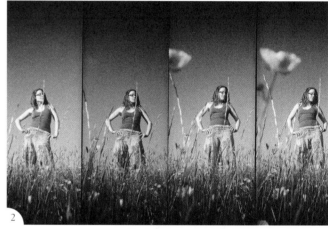

2

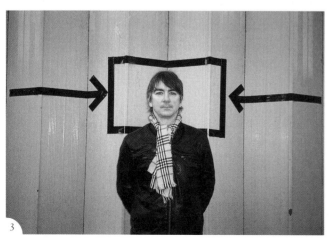

3

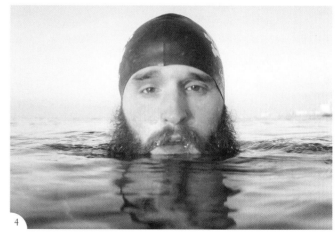

4

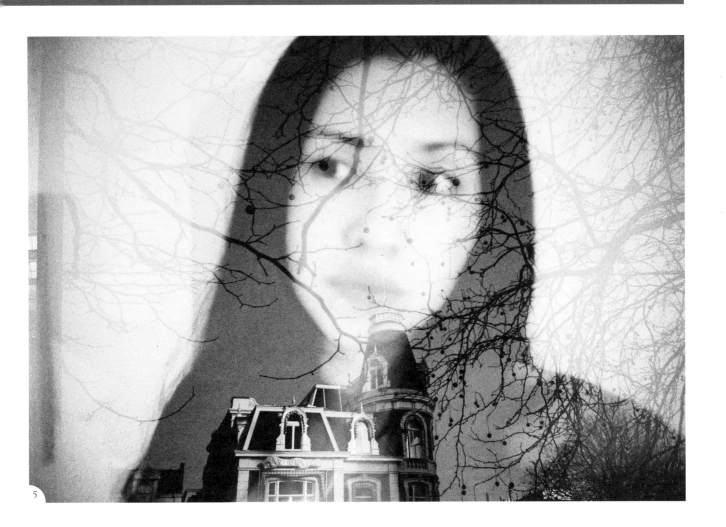

5

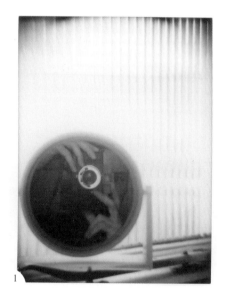

1

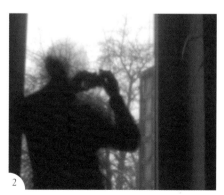

2

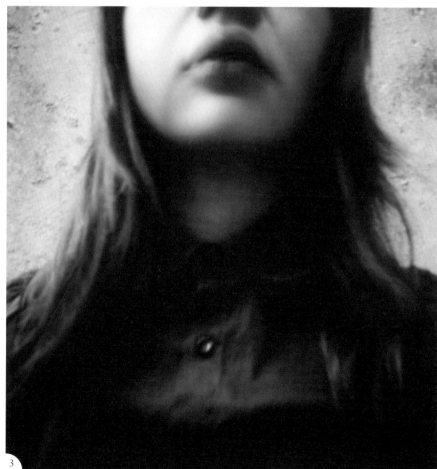

3

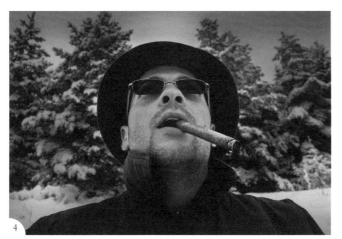

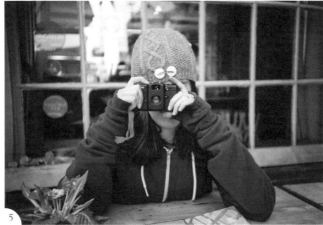

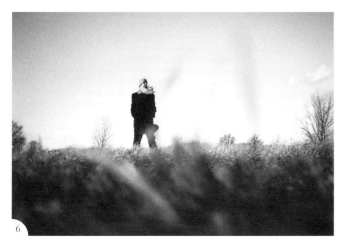

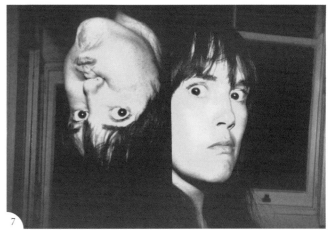

Projects for specific subjects
SELF-PORTRAITS

Photographers seem happiest when they're hiding behind a camera. This project has ideas and techniques for turning the camera on yourself for a spot of self-portraiture.

▶ HOW IT WORKS

Artists have been making self-portraits for as long as people have been around, and I think that self-portraiture is actually one of the most creative disciplines of photography. No one knows you as well as you know yourself, so, in theory, no one else can capture the various aspects of your personality as well as you can.

If you think about it, you've got the perfect model. You're always around. You're willing to do almost anything you'd ask someone else to do. You'll never have to rush to get the shot, as you'll never lose patience with yourself—unlike someone else who might get bored or fed up of having their photo taken. And the scope for having fun with your shots is practically endless.

Have a look at the difference in styles and creative approaches shown in the self-portraits on pages 094–099, and get inspired to take your own self-portrait.

▶ WHAT YOU CAN DO

There are so many techniques you can use to take a self-portrait that there really is no excuse not to try.

- Shoot into a mirror.
- Hold the camera at arm's length.
- Use a long cable release or remote to fire the camera.
- Place the camera on a tripod or solid surface and use the camera's timer function to tell it when to fire.
- Set up a shot and hand the camera to someone else.

Another way to focus your camera if you're using a tripod is to stand where you'll be in the image with your camera, and focus on the tripod. Then, when you place the camera on the tripod, it should be focused to the distance at which you'll be standing.

▶ WATCH OUT FOR …

If you're shooting into a mirror with a zone-focus camera like the Lomo LC-A, make sure you think about the distance to the reflection, and double the focus distance to the mirror.

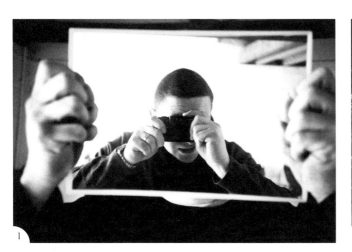

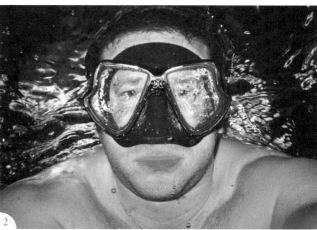

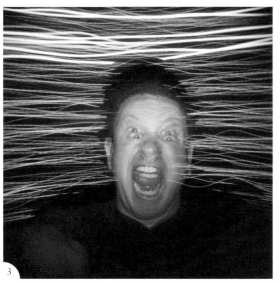

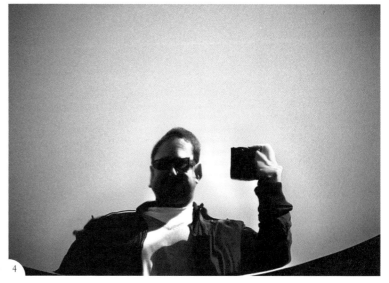

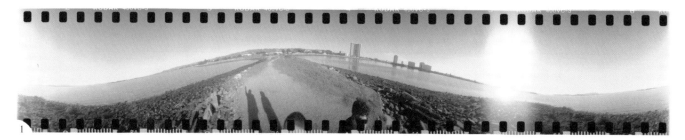

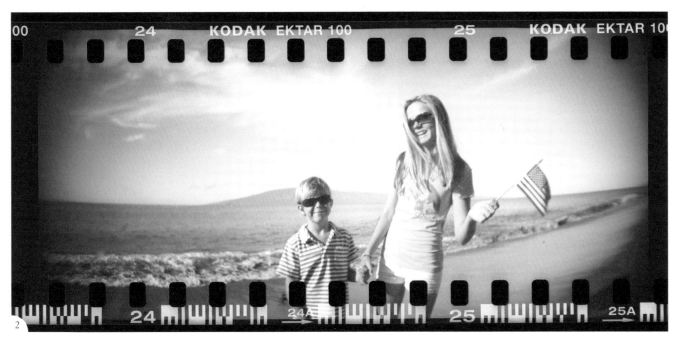

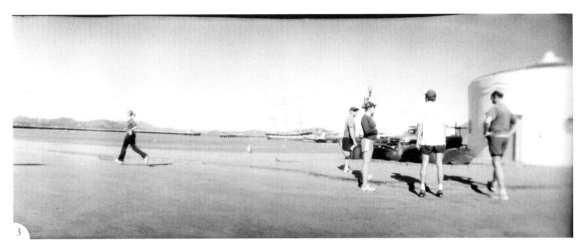

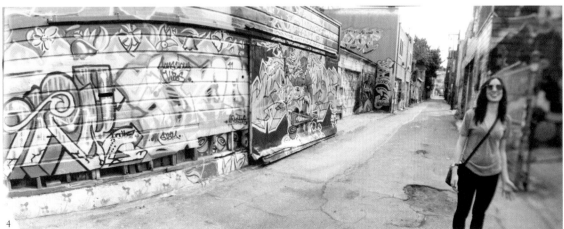

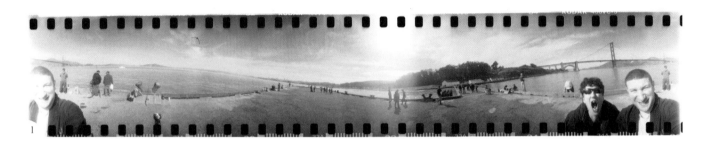

1

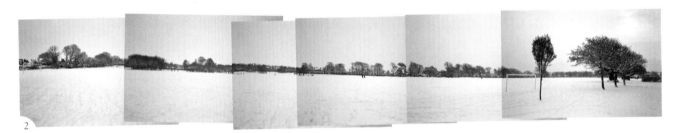

2

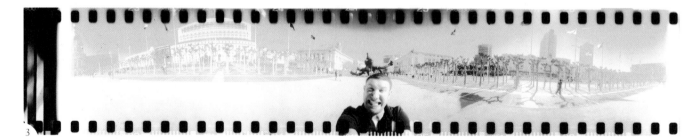

3

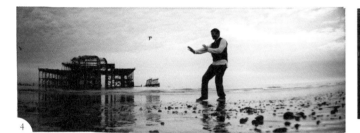

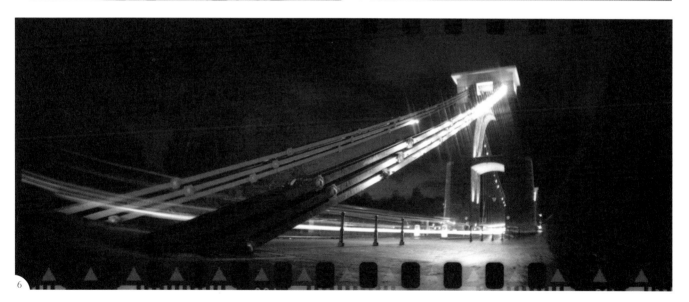

Projects for location-led photography
PANORAMIC

 This project is all about taking the wider view. With a panoramic camera, or a Holga or Diana, you can stretch not only your images, but your technical and creative skills as well.

▶ HOW IT WORKS

You've got a few options when it comes to this kind of photography. You can either buy a dedicated panoramic camera (I have focused on three that are easy to get hold of below), or you can use your Holga, Diana, or other camera.

With all these cameras, when processing, make sure you tell your lab not to cut the negatives, as you'll need to scan these images yourself.

HORIZON KOMPAKT AND PERFEKT

These cameras use standard 35mm film and produce a superwide 58mm image, with a full 120° field of vision. They have a "swing" lens, which revolves around a point in the camera and has a curved film plane, producing images with a "barrel" effect. So if you angle your camera off the level of the horizon, you'll get either a convex or a concave arc of the horizon along the length of your image. From a roll of 36 exposure film, you should get 24 panoramic images, all 58mm long.

SPINNER 360

This was inspired by a futuristic concept from the 1980s—you hold the camera in one hand and pull a cord with the other. It takes a split second for the camera to spin 360°, and capture everything around you, with a frame that's four times longer than your standard 35mm landscape frame. It's able to capture eight full 360° panoramas on a 36-exposure film, and it also shoots over the sprocket holes (see pages 008–011).

SPROCKET ROCKET

The Sprocket Rocket has a 106° wide lens. Each photo covers one-and-a-half frames of a 35mm film, so you're able to capture 18 photos on a 36-exposure film. See page 011 for how this camera also shoots the sprockets.

▶ WHEN SHOOTING

With a panoramic image, you'll be shooting a lot wider than you normally would. Think about adding interest to the whole image—not just the middle, but the edges too.

1

Use leading lines, or put people in the shot. Think about landscape shots and interesting environments. But don't limit yourself to these, as featuring people in the foreground or background can add interest.

If you're shooting a big street scene, think about the light in your composition. Is one side of the street in the sun and very bright, and one in the shade and very dark? Your image will probably have too much contrast and won't look good. Try to shoot scenes where the light is more balanced.

With the Spinner 360, as the name implies, you need to think in 360°. You might have a great vista before you, but behind you is a car park or other unphotogenic scene. Think about this when composing your shot.

Take lots of photos of a subject and combine them using your photo-editing software afterward. It's cheating, but who cares? Check out David Hockney's work for some truly memorable photomontages.

OTHER CAMERAS

You can still take great panoramic shots with a Holga or Diana. First, find a good subject. Line your camera up to the left of what you want to shoot. Take the first frame, and then wind your camera on for 18 to 20 clicks. It's about 32 clicks for a normal frame with borders. (See pages 056–057 for more on microclicks).

When you've wound on, point the camera to the right of where the first frame was taken and shoot again. Then wind the camera on another 18 to 20 clicks and continue this until you've captured your image. Shoot as many or as few frames as you like, even a whole roll of film. Your pictures won't line up 100 percent, but you should get a very interesting panoramic image.

Projects for location-led photography
UNDERWATER | GALLERY

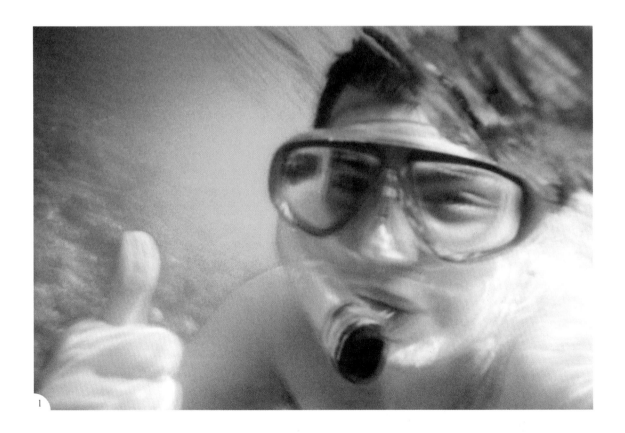

1

1 Chris Dean, Praktica Aquapix, unbranded film
2 Liana Joyce, Frogeye, Fuji Provia 400
3 Adam Bronkhorst, disposable waterproof camera
4 Adam Bronkhorst, Nikonos V, Fuji Neopan 400
5 Kevin Meredith, Nikonos V, Kodak Portra 400VC

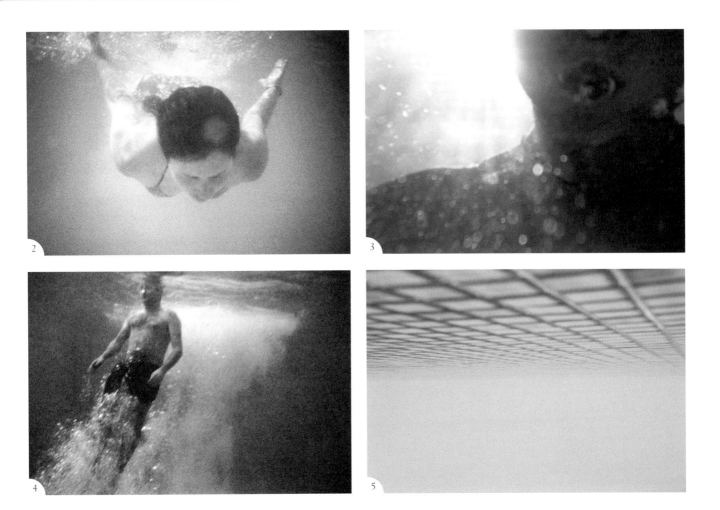

It's really worth trying underwater photography. It does mean shooting to slightly different rules and using some specialized cameras or equipment, but the results can be inspiring.

▶ HOW IT WORKS

The process of underwater photography is no different from photography on land, except that your camera must be waterproof. The camera itself can be waterproof, or you can place it in a special watertight housing.

There are many types of underwater film cameras, from disposable ones to dedicated waterproof models with changeable lenses and focus control. Try disposables first, as they're often the cheapest. You can pick up reasonably priced underwater film cameras from Nikon, Canon, and others online. Lomography also sells several underwater cameras and the Krab Underwater Housing for the LC-A.

▶ WHAT YOU CAN DO

Try keeping yourself as still as possible and just drift. Splashing about will scare off any wildlife. If you're snorkeling, try to avoid shooting all your images from above—get down and look up to get a different perspective.

Shooting people underwater always makes for good photos—we expect to see a fish, but people look unusual. Look for the way that hair floats and how people's faces seem slightly strange. Figures also give the shot scale. Try getting a silhouette of someone against the backdrop of the surface.

Take some shots where the lens is half in and half out of the water. You can use underwater cameras for any activity where water may be involved—not just swimming, but heavy rain, muddy festivals, and so on. Get creative.

Think about shooting up and into the light, and aim to capture some light streaks in the water. Try not to use the on-camera flash (unless you're in anything other than crystal-clear water), as it'll light up all the different specks and debris floating in the water.

Wide lenses are good for underwater shots, as they allow you to be close to your subject yet still capture the scene. Most cameras will have fixed focusing, but some allow you to focus manually by setting the distance to your subject. On these, set the lens to, say, 6ft (2m), then position yourself at that distance to get your subject. A fish isn't going to wait for you to focus your camera!

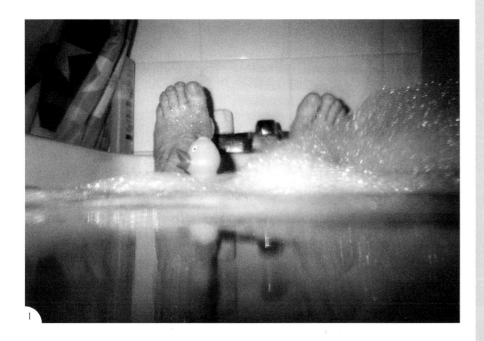

1

TAKING IT FARTHER

If you get serious about shooting while scuba diving, it's best to shoot digitally so that you won't be limited to 36 shots per dive. Proper camera housings or dedicated cameras can handle the pressure of diving down. They won't hamper your buoyancy, and they allow you to remain focused on your safety. So by all means, get started with this section, but if you're serious, use digital and dedicated cameras and take a specialized course.

▶ WATCH OUT FOR …

Water turns everything a little blue and also absorbs red and yellow light, so you'll lose a bit of color from your shot. To counteract this, I recommend using an ISO 400 film (or higher) that has good saturated color.

The farther away your subject is, the bluer and darker it'll be, so get close. Robert Capa said, "If your pictures aren't good enough, you're not close enough." Remember these wise words when you're shooting underwater.

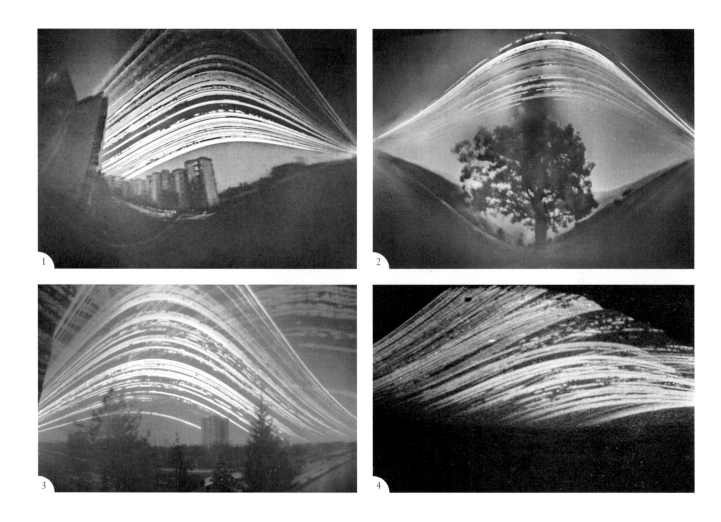

1 Boris H. Pophristov, beer-can pinhole camera, six-month exposure
2 Boris H. Pophristov, beer-can pinhole camera, three-month exposure
3 Erich Hubl, drainpipe camera, six-month exposure
4 Oddgeir Auklend, film-canister pinhole camera, one-year exposure
5 Boris H. Pophristov, beer-can pinhole camera,
 five-month-nine-day exposure

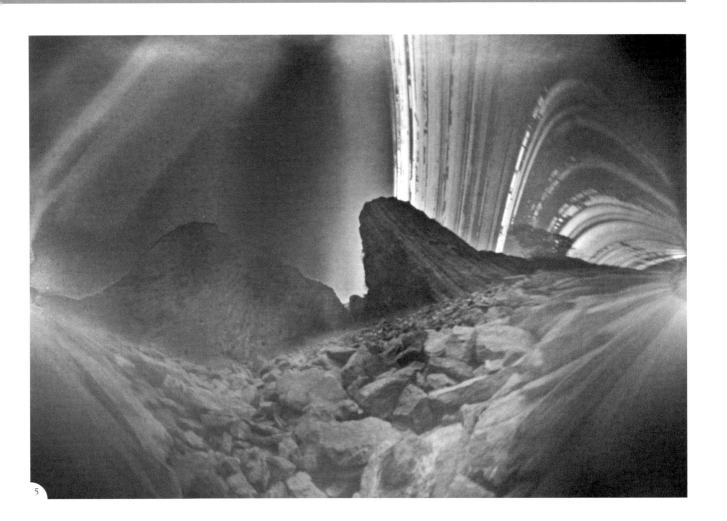

5

8 SOLARGRAPHY

This project is all about using very simple pinhole cameras and extremely long exposure times to capture the sun's light trails across the sky. Solargraphy can create some awesomely beautiful images.

▶ HOW IT WORKS

Solargraphy is the process of leaving a pinhole camera (placed facing the sun's path through the sky) in one secure location for a very long time. These very long exposures, anything from a few days to a few years, capture the movement of the sun through the sky.

The image is usually captured on photographic paper inside the pinhole camera. Because the exposure is so long, the image is often "burned into" the paper itself, so you don't have to use chemicals to develop the paper. Instead, you scan the negative you've captured and convert it into a positive image using image-editing software.

▶ WHAT TO DO

MAKE A PINHOLE CAMERA
You can make a pinhole camera out of whatever you like, as long as it's lightproof and sturdy (see pages 116–131). Film canisters are perfect for this, as they're small enough to secure to something and leave for a long time. It's a really good idea to make several cameras at once. A lot can happen over six months—they could become dislodged, or your picture may be ruined by water or mold. By using a few, you're more likely to get at least one usable image. You can also stagger the exposure times by opening one a month for a few months.

INSERT PHOTO PAPER
Get some black-and-white photo paper, with a very low ISO (between 5 and 10; a good example is Ilford Multigrade IV FB Fiber). Remember to place the paper with the emulsion side facing the pinhole so that it'll capture the light. You don't want to return to your cameras in six months time to find you set up your camera wrong! Also, make sure that the paper doesn't cover up the pinhole.

FIND A LOCATION
Look for places where the sun shines directly all day, or where the sun sets or rises. That way you can record the path of the sun. Secure your cameras very firmly, as you don't want them falling off or moving with the wind. Try to include something of interest in your shot that you know won't move over the months. Buildings and trees are always good. Either mount your camera upright for a traditional image that includes some landscape, or on its back to just record the path of the sun in the sky.

COLLECT YOUR CAMERA
How long you leave your camera is totally up to you. Anything from one day to six months is good. Try for one to two months first. See what the images look like, and take it from there. After you've collected your camera, carefully remove the paper (dry it with a hair dryer if necessary), and you should see the image already on the paper. There's no need for any chemicals. After such a long exposure period, you should see the tracks of the sun

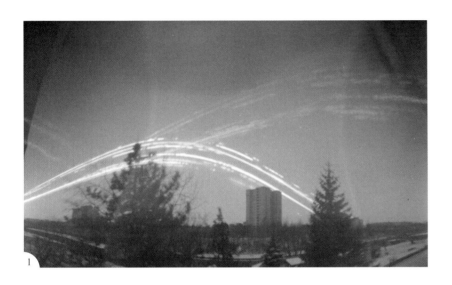

1

on your photographic emulsion. The image you've captured will be a negative, so you need to scan your exposed paper and invert the image in photo-editing software. Adjust its contrast and brightness if needed.

Your images may have a unique aged feel to them—something you certainly won't get from a modern DSLR. Don't be surprised if you manage to get a color-tinged image from black-and-white paper. Solargraphy has the power to produce the unexpected.

OPTIMUM DATES

There are certain time frames that are particularly good exposure periods for solargraphy. If you shoot between a solstice and an equinox, or vice versa, you will capture the greatest range in movement of the sun across the sky. Exact dates will vary slightly depending on the calendar year, but the following provide a good guide:

- December 21 (solstice)—March 20 (equinox)
- March 20 (equinox)—June 21 (solstice)
- June 21 (solstice)—September 23 (equinox)
- September 23 (equinox)— December 21 (solstice)

TAKING IT FARTHER

Film canisters are a great way to start in solargraphy, but many people like to use bigger containers for their pinhole cameras. This allows you to use larger film and get a bigger negative, so you get more contrast and detail in your final image. Try paint or coffee cans or anything that's tough enough to leave outside for six months.

Projects for pinhole photography
PINHOLE BASICS

A pinhole camera is the simplest form of camera. It's basically
a lightproof box with a very small hole in one end and photographic
paper or film in the other. It really can be that straightforward.

 ## HOW IT WORKS

Light enters the camera through a very small hole rather than a lens. A pinhole camera only has one aperture setting and the most basic of shutters. As big or as small as you like, it can be made from all kinds of materials: a 35mm film pot can be ideal (see page 130), while in 2006, an aircraft hanger was used to create the world's largest pinhole photograph.

The light from your subject passes through the small hole and projects an upside-down image onto film or photographic paper at the other side of the box. Pinhole images can suffer from being quite soft, and anything that moves will be rendered as a blur, but this is often what people like about them; it gives them a distinct, dreamy, vintage look. For some specific pinhole projects, see pages 112–115, 118–123, 124–127, 128–131, 140–143, and 157.

 ## WHAT TO DO

When you're building and using a pinhole camera, think about the following:

- The size of the pinhole. The smaller it is, the sharper the image—but the longer the exposure time.
- Where you place the pinhole in relation to your film or paper affects the field of view. So the farther away from the film plane the pinhole is, the narrower the field of view will be. The closer to the film plane, the wider the field of view.
- Focusing. As there's no lens, there's really no limit to how close or how far away you can focus—pinholes have a nearly infinite depth of field.

Because the aperture size is so small, exposure times are very long (you can go as long as three years if you like). Therefore, you don't have to be as precise with the shutter speeds. You can just use a lens cap, or a basic flap instead; removing it is like opening the shutter, and replacing it like closing the shutter.

 ## WHEN SHOOTING

Bracket your shots to ensure you get a good-enough exposure. Use an exposure chart based on what you think your pinhole camera's aperture is as a starting point (see right).

Calculate the f-stop of your camera by scanning your actual pinhole at 600 dpi and counting the pixels across your pinhole. Divide the number of pixels by 600. That gives you the measurement of your pinhole in inches. Measure the distance from the film to the pinhole—this is the focal length of the camera. Divide the focal length by the pinhole's diameter, and that gives you your f-stop. So to recap: f-stop = focal length ÷ pinhole diameter.

DON'T BE PUT OFF IF …

Don't worry if your f-stop doesn't coincide with an exact value. You don't need to be too exact, but it's always better to round up your f-stop to the next full stop, as pinhole exposures are more likely to be under- rather than overexposed.

Look online for some very handy websites that will calculate your f-stop for you and give you exposure values, too. Handheld light meters are also extremely useful for telling you which shutter speed you need, if you can work out your settings from factoring up the exposure. Alternatively, take a reading using the light meter on your SLR or other camera.

CALCULATING EXPOSURE TIMES

Use this chart as a starting point for your exposure times. It's useful to carry one with you when shooting with a pinhole camera, but don't be a slave to it. Don't worry if you're not 100 percent accurate. Although pinhole photography is a science, it's also an art.

F-STOP CALCULATION

Camera length (in/cm)	Needle size	Diameter of hole (mm)	Relative f-stop
8/20	8	0.8	f/350
6½/16.5	9	0.5	f/300
5/12.7	10	0.45	f/280
4/10	12	0.4	f/250
2½/6.3	13	0.3	f/190

EXPOSURE TIMES

Weather conditions	f-stop	Photo paper	ISO 100 film	ISO 400 film
Bright or hazy sun	250	49 secs	2.8 secs	1 sec
	300	1.3 mins	4.6 secs	1.25 secs
	350	2.1 mins	7.1 secs	1.5 secs
Bright sun, intermittent cloud	250	2 mins	6.7 secs	1.3 secs
	300	3.3 mins	11 secs	2.2 secs
	350	5.1 mins	17 secs	3.4 secs
Cloudy, but bright, no shadows	250	5.4 mins	18 secs	3.6 secs
	300	9 mins	31 secs	6 secs
	350	14 mins	47 secs	9.2 secs
Overcast/ open shade	250	14 mins	47 secs	9.2 secs
	300	23 mins	1.3 mins	15 secs
	350	36 mins	2 mins	1 minute

Thanks to Pinhole.org for help with this chart.

Projects for pinhole photography

COOKIE-TIN PINHOLE | GALLERY

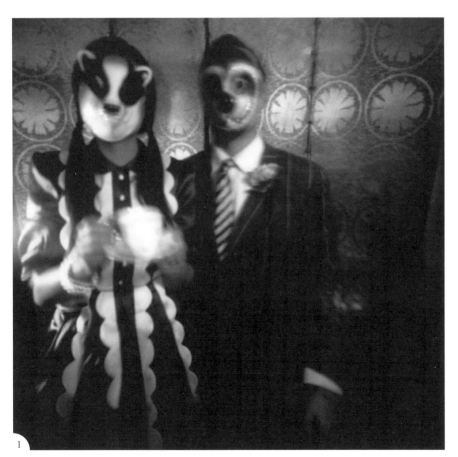

1

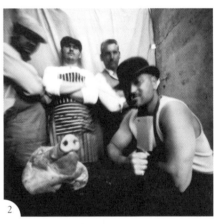

2

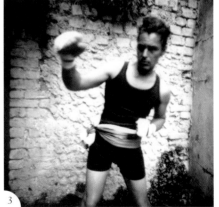

3

1 Cookie-tin pinhole camera
2 Cookie-tin pinhole camera
3 Cookie-tin pinhole camera
4 Cookie-tin pinhole camera
All photos on this spread by Nhung Dang

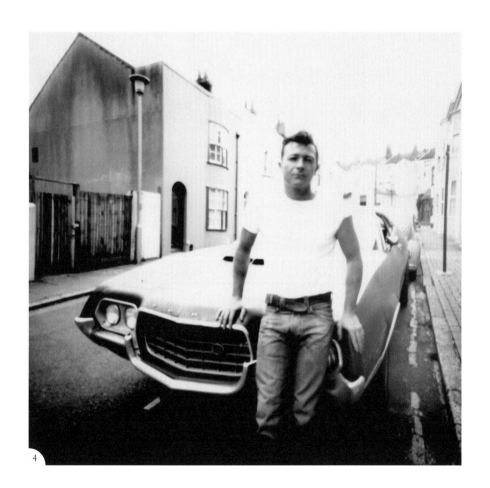

4

9
COOKIE-TIN PINHOLE

A great place to start with building pinhole cameras is with a cookie tin or shoebox.

▶ HOW IT WORKS

This project is ultrasimple, made from easy-to-find things at home, and opens the door to hours of fun with your very own DIY camera. Cookie-tin pinhole cameras are very easy to make, and you'll soon fall in love with your ugly-beautiful creation.

▶ WHAT TO DO

Clean the box and spraypaint it black inside. Make sure you're starting with a clean box with no bits of fluff or cookies inside. Once you've cleaned it, you need to make it light-tight. Take some matte black spray paint and cover the insides and lid of your box evenly. Let it dry, and repeat if necessary. Don't leave any shiny metal exposed, as this will cause light to bounce around your camera, which can ruin your film.

CUT A HOLE ON ONE SIDE
Along the shortest side of the shoebox, or one side of the cookie tin, carefully cut a round hole about half an inch (1.5cm) in diameter. On the cookie tin, smooth down any rough metal edges around the hole with some sandpaper if needed.

MAKE YOUR PINHOLE
Cut a 2in (5cm) square piece of heavy aluminum foil, or for something sturdier, cut out a piece of an aluminum soda can. Take a size-10 needle and carefully poke a hole through the middle of your square, turning the needle to ensure a smooth-edged hole. You should aim for a hole about 0.5mm in diameter. If you've used part of a soda can, smooth the back of the hole with some fine sandpaper, as any roughness will affect the picture quality. After sanding, poke the hole again. Hold your pinhole up to the light and make sure it's perfectly round.

POSITION YOUR PINHOLE
Tape your tin square to the inside of your box so that the pinhole is in the center of the bigger hole you made earlier. Tape all around the edges of your square to prevent any light from creeping in.

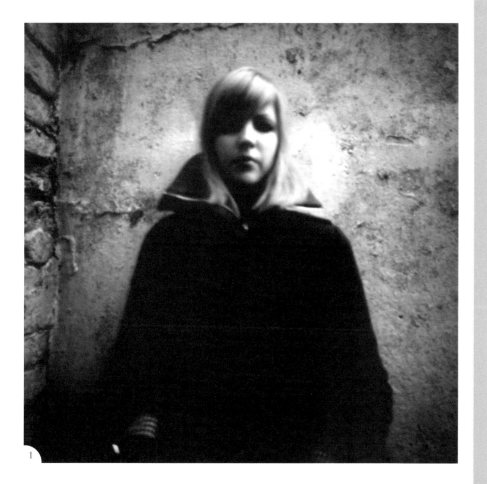

1

WHAT YOU'LL NEED

- a shoebox or cookie tin with a removable lid
- matte black spray paint
- insulating tape
- aluminum foil or a soda can
- fine sandpaper
- small piece of card stock
- a size-10 needle
- photographic paper

COOKIE-TIN PINHOLE CONTINUED

MAKE A SHUTTER

Cut a piece of card stock big enough to totally cover the hole you cut in the side of the box or tin. Wrap this card in black insulating tape. You need to make a hinge for your shutter so you can lift it when you want to take a shot and then close it so it's lighttight. To do this, position the tape-covered card over the hole, secure it along the top edge, and leave some loose tape around the other edges, so the shutter opens; when you want to close it, just stick it down firmly.

LOAD YOUR CAMERA

Go into a completely dark room and load your camera with photographic paper. Cut the paper if you need to so that it'll fit into your camera on the side opposite your pinhole. Load the paper with the light-sensitive emulsion facing the pinhole, then close the lid and tape around the edges and anywhere that light could get into your camera.

TAKE YOUR SHOT

Place your camera on something very sturdy and point the pinhole end at your subject. When you're ready, lift the flap. To determine the right exposure time for your aperture, you need to experiment a bit. See page 117 for a general guide to exposure times. There are helpful guides online, too.

DEVELOP YOUR FILM

When you've taken your shot, take your camera back into a dark room and remove the paper. Either develop it yourself using the usual chemicals (see pages 042–043 and 046–047), or take the pinhole camera or paper in a lighttight holder to your local high-end camera store or professional lab and get them to develop it for you.

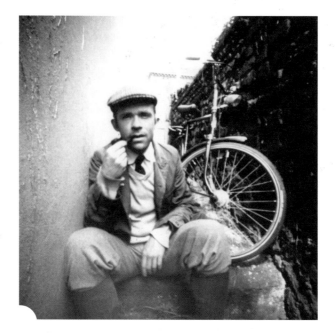

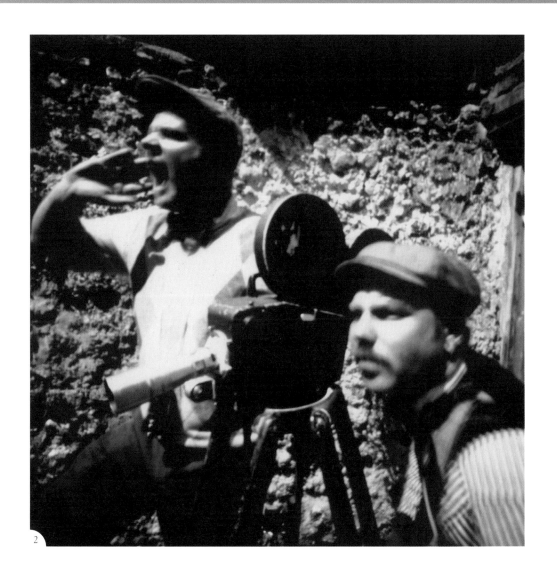

2

1

1 Olympus OM-1 SLR pinhole, Fuji Superia
2 Olympus OM-1 SLR pinhole, Kodak Gold
3 Olympus OM-1 SLR pinhole, Kodak Gold
4 Olympus OM-1 SLR pinhole, Ilford HP5
5 Olympus OM-1 SLR pinhole, Fuji Neopan 400
All photos on this spread by Adam Bronkhorst

Projects for pinhole photography
SLR PINHOLE

With a few simple adaptations to your SLR film (or digital) camera, you can create a brand-new pinhole camera. The great advantage of this technique is that you'll have up to 36 exposures to play with.

▶ HOW IT WORKS

This works on the same principle as making any pinhole camera, but you use the body cap (the plastic cover you use on the camera when you've removed the lens) of your SLR for the pinhole and the SLR body as the camera.

Turning your SLR into a pinhole has several advantages. One is that you only need to build part of a pinhole camera for this to work. But the main advantage is that you can shoot on a roll of normal 35mm film with up to 36 exposures. Even better, you can take your film to a normal lab and get them to do all the hard work in developing the film.

▶ WHAT TO DO

The first step is to drill a 5mm hole in the very center of your camera's body cap. Then take a small piece of aluminum foil and make a 0.2mm hole in that. Sand the front, the back, and the edges, and hold it up to a light to ensure that you have a perfectly round, smooth hole. Tape the foil to the inside of the body cap, with the pinhole in the center of the 5mm hole in the body cap. Ensure that no light can leak in around the edges of the aluminium foil by using black insulation tape.

▶ WHEN SHOOTING

When you have your body cap with your pinhole in it, place it on your camera and start shooting.

Set your camera to manual, but just for the shutter speed. As you're not using a normal lens, there's no aperture to adjust. So you need to be able to adjust the shutter speed to the correct exposure. Don't worry if you're not pinpoint accurate.

If you've made your hole 0.2mm wide, you should have a focal length of 50mm and an aperture of f/256. You should now be able to calculate your exposure times. Have a look at the chart on page 117 for more help. For a pinhole exposure, you're looking at shutter speeds of seconds rather than fractions of seconds.

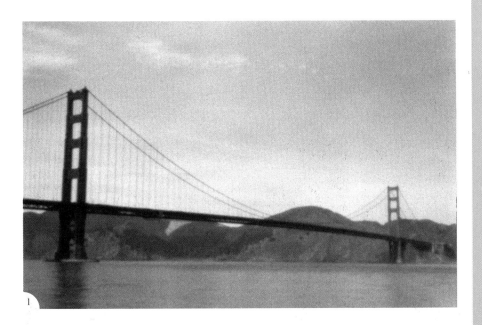

1

WHAT YOU'LL NEED

- body cap for your particular
 SLR camera
- aluminum foil (or aluminum soda can)
- needle
- very fine sandpaper
- black insulation tape
- something to drill a small hole
 through the cap

MAKING IT EASIER

If this is all a bit much for you, or you're
not that handy, there are several websites
where you can buy readymade pinhole
body caps for a number of SLR makes.
These have been precisely cut with a laser,
and some come with a thin bit of plastic
over the hole to stop dust from getting
into your camera.

Projects for pinhole photography
OTHER OPTIONS | GALLERY

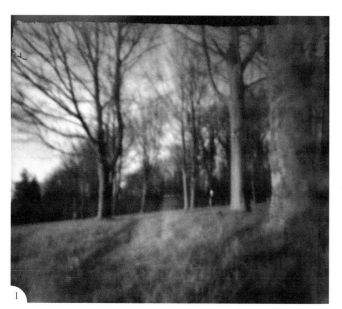

1

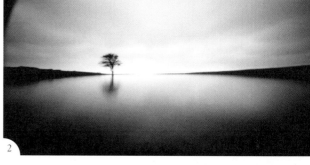

2

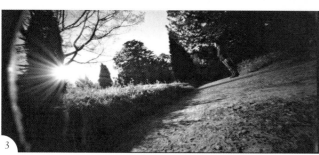

3

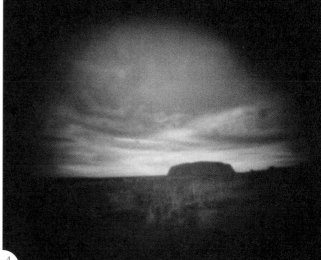

4

1 Graham Lally, homemade matchbox-pinhole camera
2 Graham Lally, Holga 120 WPC, Kodak T-Max 400
3 Graham Lally, Holga 120 WPC, Ilford HP5 Plus
4 Nhung Dang, 110 pinhole camera

5 Adam Bronkhorst, PinHolga, Fujicolor Superia 100
6 Adam Bronkhorst, PinHolga, Fujicolor Superia 100
7 Adam Bronkhorst, PinHolga, Fujicolor Superia 100
8 Adam Bronkhorst, Lomo LC-A, Fuji Sensia 200, cross-processed

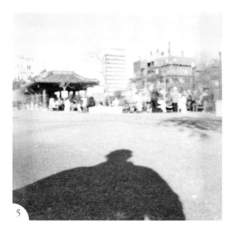
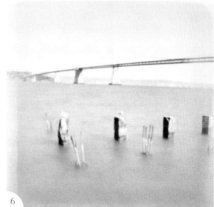
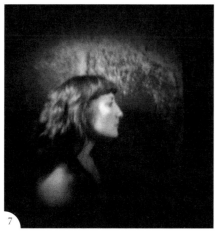
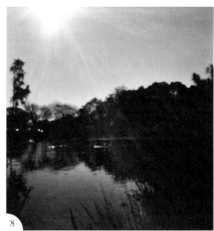

Projects for pinhole photography
OTHER OPTIONS

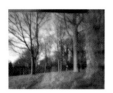

This project takes a look at more ideas for creating pinhole cameras, some straightforward, some rather more unusual. There's really no limit to what you can use to make a pinhole camera.

▶ HOW IT WORKS

You can adapt the pinhole principle to almost anything. I've seen Spam tins, juice boxes, old Apple computers, soup cans, pumpkins, even a pine nut all used to make pinhole cameras. I'm not saying they're perfect, but they still work along the same lines.

In 2006, an intrepid bunch of people decided to make the world's largest pinhole photo: 108ft (33m) wide and 85ft (26m) tall. They managed to turn an entire aircraft hanger into a lightproof room and used a pinhole of ¼in (6mm) diameter to expose the print. And they needed an Olympic swimming pool–size tray to develop the print.

▶ WHAT TO DO

MATCHBOX PINHOLE
Here's a very effective way to use a matchbox and two rolls of 35mm film to make a pinhole camera. You make a 0.2mm pinhole out of aluminum foil and fix it to the center of the box's sleeve. Make the inside of the matchbox lighttight by covering it with black tape or spraypainting it black.

Take one full roll of 35mm film and one empty 35mm film canister with a little bit of film left on the end. In the inside tray of the matchbox, cut a 1½ × 1in (36 × 24mm) hole to make a mask for the film and to hold the film to the back of the matchbox. Thread the end of the film of the full canister through the match tray. Make sure the emulsion side of the film is facing the pinhole. Slide the tray back into the box.

When the film has been threaded through, tape its end, with thin clear tape, to the little bit of film left on the empty canister. The canisters should sit snugly next to the matchbox, with no film visible. Now tape the whole camera up so that it's lightproof. Make a shutter for the camera with a piece of black tape that you can lift up and fix back down after the shot.

Once you've taken your shot, turn the spindle of the empty canister to wind the exposed film into the empty canister. The matchbox pinhole camera has an aperture of about f/90. If you're using ISO 100 or 200 film, and you're outside in sunshine, expose for 1 or 2 seconds. If you're outside and it's cloudy, expose for 5 seconds. If you're inside and it's normal room lighting, expose for 5 to 10 minutes. Develop the film through your usual lab.

BUILD-YOUR-OWN KITS

You can always buy a specialist pinhole-camera kit that includes all the materials you'll need. There's a wide variety of kits available, including plastic cameras or cameras made from card. These can be very affordable and are immense fun to build.

READYMADE

If you don't think you're up to making a pinhole camera, you can always buy a ready-made one. There are some truly beautiful wooden models out there. These cameras are a work of art in themselves and feature some fantastic engineering.

ADAPT AN EXISTING CAMERA

There are also various options available for converting existing cameras. You can adapt an SLR (see pages 126–127) easily. The Holga camera can be converted into a PinHolga (see page 142). The Diana F+ actually comes with a pinhole lens. These are great ways to get into pinhole photography without the worry of making anything or the hassle of developing photo paper.

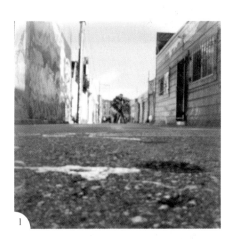

1

1

2

10 TAPING AND FLOCKING

The Holga is a wonderfully basic camera. One of the simplest things you can do, with just some tape and black spraypaint, is to protect your camera against light leaks.

▶ HOW IT WORKS

Thanks to its simplicity of design, and the fact that it's made of soft plastic (which can be cut, carved, snapped, drilled into, and glued onto), the Holga lends itself to being adapted or modified to suit your particular needs. On these pages, and on pages 136–143, I've given you some ideas to get you started in the world of Holga mods. I've started here with a very simple modification.

▶ WHAT TO DO

TAPING

Some Holgas come with internal masks, which make your images either square or rectangular. But you can shoot without masks as well. You'll still get a square image, and there's more chance you'll get some vignetting.

If you're shooting without masks, a quick and easy mod you might like to try is to tape up the sharp plastic bits at the sides of the exposure opening. You can use black insulation tape for this—just make sure that when your film is wound on, it's now rolling over your nice smooth tape rather than sharp plastic, which may scratch the film.

Some people really go to town and tape up anywhere on a Holga that might leak light, which could ruin film, protecting the insides at particularly vulnerable points. Try taping up the red window from the outside and all around where the removable back of the camera meets the camera itself—basically anywhere you think light can creep in.

But take note, as many Holga shooters see light leaks as a good thing and integral to the Holga/lo-fi look. Light leaks add fogging or different-colored aspects to the photo. They often produce very unpredictable results (see image 4 on page 133).

FLOCKING

As the Holga's made of plastic, it can be
very shiny on the inside. This shine increases
the risk of light leaks and lowers the overall
contrast of your images. One solution is to
spray the inside of your Holga with matte
black paint. Make sure you don't spray
the internal workings of the camera, or the
shutter, as you may clog it with paint and stop
it from opening. Cover up the square hole
behind the shutter and the red window on the
back of the Holga with black insulation tape.

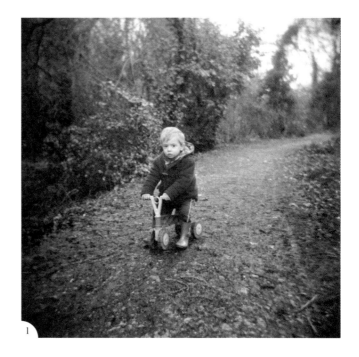

1

Projects for adapting Holgas
CLOSE-FOCUSING | GALLERY

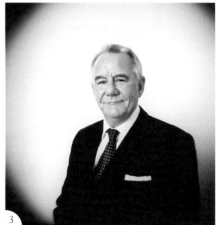

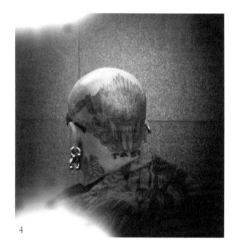

4

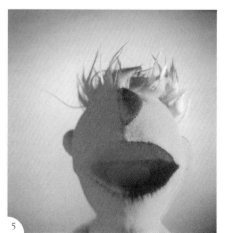

5

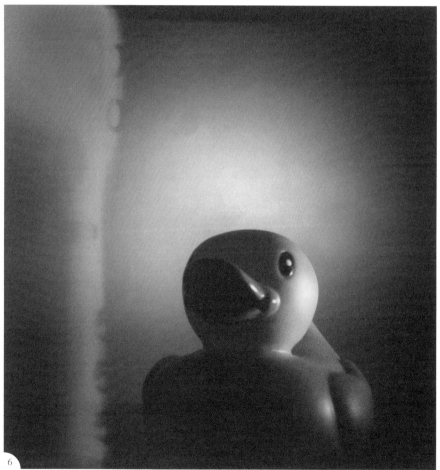

6

This project shows how you can adapt your Holga to get right up close to your subjects. The methods range from buying straightforward add-ons for your camera to trying out some radical lens surgery.

▶ HOW IT WORKS

Either invest in some new add-ons for your camera, or, if you're feeling brave, adopt a more hands-on approach and take the actual lens off to adapt it as you need to. Because the Holga is so easy to break and shape, it's not as difficult as it sounds.

▶ WHAT TO DO

DIOPTERS AND LENS KITS
The first method is to use a set of close-up filters (also called diopters). You can get these quite cheaply on Internet auction sites, and they usually come as +1, +2, and +4 filters. These can then be stacked to form other values. Just set your lens to infinity focus (mountain symbol) and shoot away. I would recommend you get some 49mm diameter ones for a Holga. These should slot very firmly into the lens barrel if you slightly sand the inside edge of the lens's outer lip.

You can always buy one of the dedicated close-up lens kits that are available for the Holga camera. Some of these allow you to focus as close as an incredible 1⅛in (3cm) to your subject.

DIY LENS ADAPTING
Turn the lens to the close-up setting. Hold the Holga's body in one hand and the lens in the other and twist until you hear a disarming crack. Your lens may come all the way off in your hands, but it's OK. If you get the threading right, most of the time it will twist back on the camera body with the old stopping point keeping it from falling off. You can now turn your lens to focus closer than the standard 3 or 4ft (1 or 1.2m).

Slightly more complicated, but essentially the same idea, is to take the camera apart by unscrewing the shutter assembly and lens from the inside, and to grind off the stopping point on the lens and fashion a new one. For this, you can use a very small screw, or glue a piece of plastic the same size and shape as the one you've removed. Fix that in place to allow your lens to focus closer, then reassemble your camera.

1 Holga, Kodak Portra 400VC
2 Holga, Kodak Portra 400VC
 Both photos on this page by Adam Bronkhorst

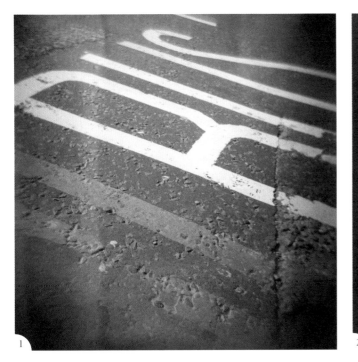

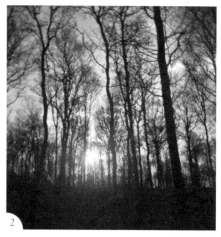

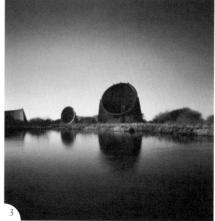

1 Adam Bronkhorst, Holga, Lomography RedScale
2 Adam Bronkhorst, Holga, Kodak Portra 400VC
3 Simon Tomlinson, Holga, Kodak Ektachrome E100G
4 Simon Tomlinson, Holga, Ilford FP4
5 Simon Tomlinson, Holga, Ilford FP4
6 Adam Bronkhorst, Holga, Ilford HP5

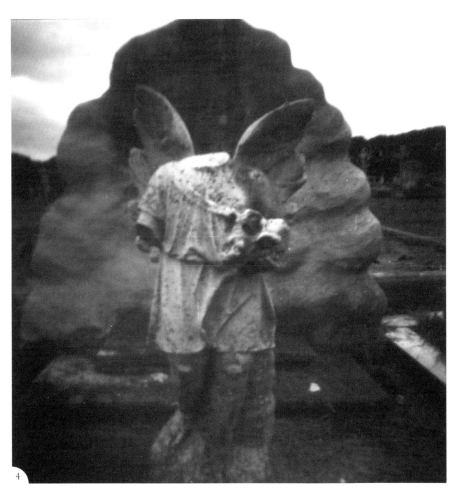

4

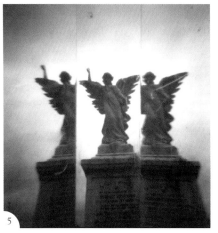

5

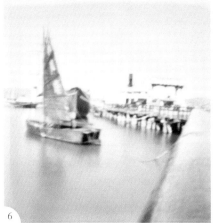

6

Projects for adapting Holgas
PINHOLGA

This project shows how, with a few alterations and some cheap materials, you can transform your Holga into a pinhole camera. This will give you the chance to experiment with much longer exposures.

▶ HOW IT WORKS

To make a pinhole camera from your Holga, you need to remove the lens and create a new aperture in the form of a tiny pinhole. For more on making pinhole cameras, see pages 116–131.

▶ WHAT TO DO

First, remove your Holga's lens. You can unscrew it completely from the inside or from the outside, depending on the model. You could also rescue a broken Holga if its lens has been snapped off.

Then, cut a section of an aluminum can, foil, or baking tray to a size large enough to cover the hole where the lens was. I've also seen the lid of a jar used. Whatever you're using, pierce this with a hole to make a tiny aperture—the actual size is up to you, and you can experiment with this.

Tape this to the front of the Holga and make sure that either the shutter works or you have something to cover the pinhole (like the lens cap) that can act as a shutter. Get a hold of a guide that tells you how long your exposure needs to be. See page 117 for a good starting point. You'll need to work out what the rough aperture value is to gauge the exposure. Now, go shoot something.

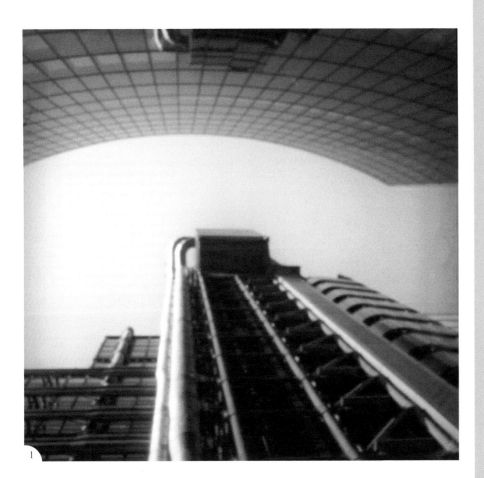

1

OTHER MODS

There are lots of other modifications that can be done to the Holga, like adding a Polaroid back to the camera—also known as making a Holgaroid. You could add a shutter-release cable, filter holders, a tripod mount, and so on. That's the great thing about a Holga; it's such a great platform for adapting to how you want to shoot. But if you want to be truly radical, you could always use it straight out of the box.

1

2

3

4

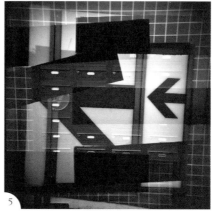

5

6

USING MASKS

By using masks, you're no longer limited to taking square or rectangular pictures. Masks give you the chance to vary the shape of your images, and they can also add color to your photos.

▶ HOW IT WORKS

Camera masks are designed to let you change the shape of the image that you want to shoot. A mask is a piece of cardboard, cut out to a particular shape, that sits between your lens and your camera plane to block off or mask parts of the frame that are usually exposed.

Some cameras like the Blackbird, fly; Holga; and Diana already come with their own masks. These allow you to shoot a square image or rectangular image, or you can take the mask out completely and get lovely soft edges (known as vignetting) on your negative.

By experimenting with masks, you can create really interesting borders, frames, or shapes on your images. So who says we need to have square or rectangular images—why not have them circular, star-shaped, or with words written over them?

▶ WHAT YOU CAN DO

All you need to do is to make a mask out of black card, thin plastic sheeting, or transparency paper, and ensure that it's a little bigger than the exposure opening in your camera. Fix it in place (upside down) with tape, without interfering with the workings of the camera.

You can get really creative. Rewind the film, change the mask, and then shoot the roll again as an experiment with multiple exposures (see also pages 058–061). One of the best methods I've seen for doing this is where a mask with a cutout in the middle is used to shoot, say, some people. Then use a mask with the middle of the frame blocked out, and the edges exposed, to shoot textures or colors, for example. That way, you can create your own frames for your images.

Take it one step farther. Think about printing something out onto a sheet of transparency paper. Print words, patterns, anything you like that you think will make a good imprint on your image. You can even used colored gels between your lens and your film (see pages 076–079). Stick a blue gel in there, and all your images will be blue. Make a template up that has the Union Flag on it, and all your images will be colored like the flag.

But there really are no rules with this great technique. The more creative the idea, the better.

1

Projects for adapting cameras
CAMERA CREATIONS | GALLERY

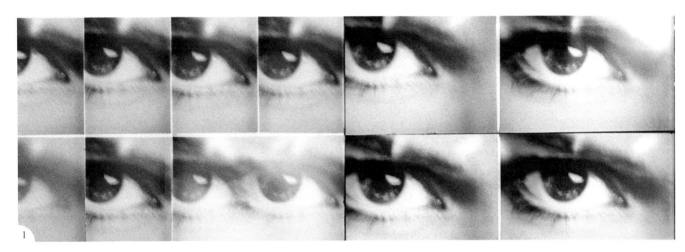

1

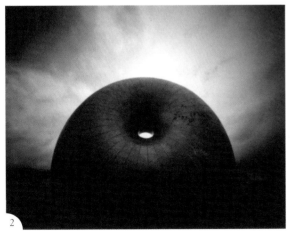

2

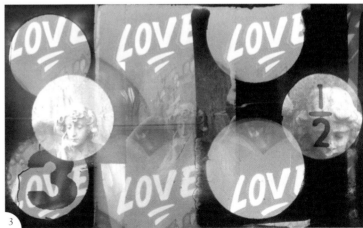

3

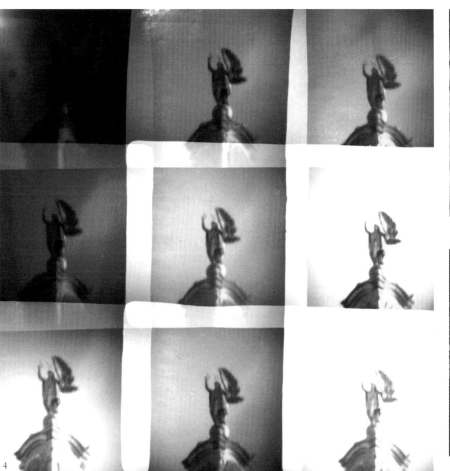

Projects for adapting cameras
CAMERA CREATIONS

This involves taking two or more cameras, or different camera parts, and combining them to create something new. It's not the easiest project, but the more technically minded will love tackling this head on.

▶ HOW IT WORKS

If you've got two cameras that are both broken, but you think that you could combine them to make a working camera, no matter how ugly, give this a try.

Think about the basic elements of a camera—lens, shutter, something to capture the image (film, paper, instant film, etc.), and something to hold them all together. As long as you have a good idea of how a camera works, you should be able to think about how you can convert or make cameras to suit your needs. Just make something that no one has ever seen before, and wait for those looks of shock and surprise when another photographer sees you using your creation.

▶ WHAT YOU CAN DO

You're not happy with the viewfinder of one camera but love the rest of it. You also have a camera with a brilliant viewfinder, but you can't get the film for it, and it's gathering dust. Try combining the two.

You may have a basic old box camera, but with a little tweaking here and there, you can convert it to your needs. You can change the lens, convert it to a pinhole camera, add a viewfinder, or use a different type of film inside it—anything that fits your requirements.

Adapt an old camera to shoot with a Polaroid back. Or modify your Polaroid to shoot with another brand of instant film.

This one's not the easiest project, but you can adapt your camera with LEGO mechanics and electric motors to make it shoot a whole roll of 120 film in one go, capturing 360° of vision. I've seen this done with a Lubitel TLR camera.

▶ WATCH OUT FOR

Make sure your creations are lighttight, as you don't want stray light getting onto your film. Spray the insides with matte black spraypaint, or use black insulating tape all around the camera.

If you're taking the lens from one camera and fixing it to another, it can be tricky getting the lens in the right position on the camera body. A neat tip is to open the camera back, get a flat piece of plastic (the lid of a small plastic storage box will do), and hold it where the film would be positioned. Open the camera shutter, and you should see a projection of the image that the lens will see on the plastic.

Next, attach your new lens and look again to see if the image on the plastic is sharp. If it isn't, move the lens either closer or further away until the image comes into focus. When it does, you've found the right position to fix the lens.

1 Modified Brownie, Fuji Provia 100F
2 Homemade camera, Ilford Pan F
Both photos on this page by Simon Tomlinson

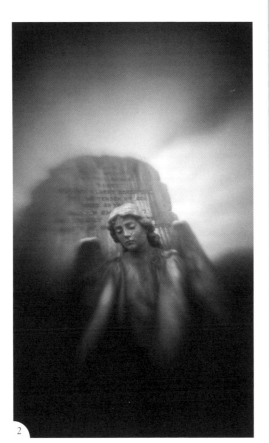

WHAT YOU'LL NEED

- glue
- craft knife
- black tape
- small screwdrivers
- needle-nose pliers
- drill
- small screws
- lots of time

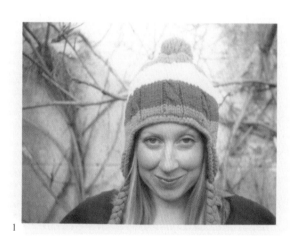

1

2

3

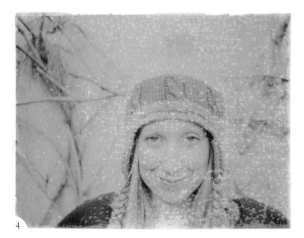

4

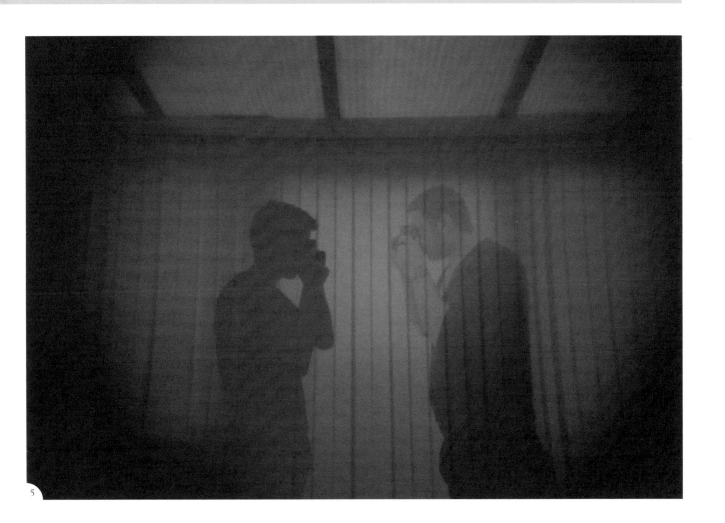

5

COMBINING TECHNIQUES |
GALLERY CONTINUED

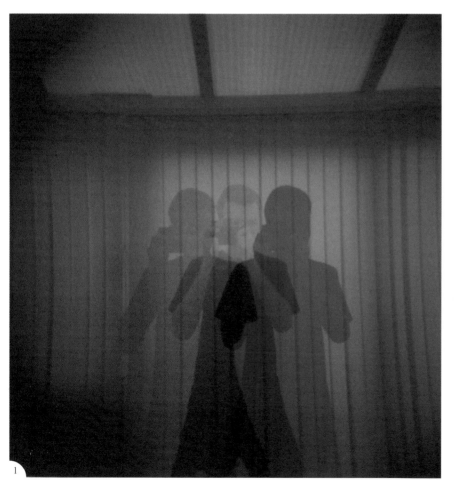

1

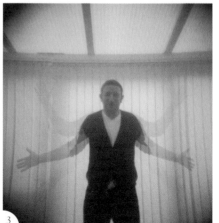

2

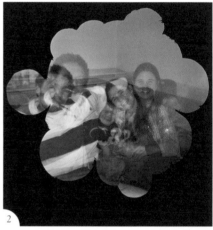

3

1 Adam Bronkhorst, Holgaroid, camera creation/
 multiple exposure/colored gels
2 Adam Bronkhorst, Holga, paper mask/colored flash/
 multiple exposure
3 Simon Tomlinson, Holgaroid, camera creation/
 multiple exposure/colored gels

4 Adam Bronkhorst, Nikonos V, underwater/push processing
5 Adam Bronkhorst, Nikonos V, underwater/push processing
6 Michał Małkiewicz, soda-can pinhole camera, solargraphy/
 paper mask
7 Adam Bronkhorst, Holga, colored flash/long exposure
8 Adam Bronkhorst, Diana F+, long exposure/pinhole

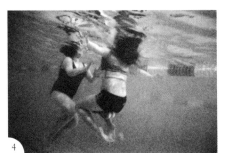

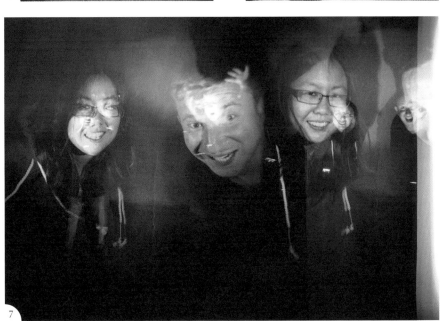

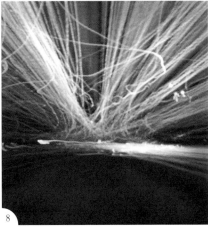

12

Projects for the next step
COMBINING TECHNIQUES

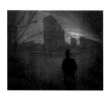

If you've tried out a few projects, your creative juices now should now be truly flowing. Start to think about how you can combine some of them to open up yet more possibilities.

▶ HOW IT WORKS

You'll find that some particular projects work well in combination. By knowing about the different projects in this book and by combining some of them, you should be able to make even more interesting images. Some of these combinations are similar but deliver very different results.

▶ WHAT YOU CAN DO

IMAGE TRANSFER/EMULSION LIFT/ BLEACH THE NEGATIVE

By using all three of the techniques described in Chapter 2 (pages 020–029), it's possible to get four different versions of the same image (see images 1–4 on page 152). Shoot an image on peel-apart film. When you're ready, pull the negative and use the image-transfer technique. Next, scan the original print so that you have a digital copy. After scanning, use the emulsion-lift method with the original print. Once you've done all that your negative should be dry and you can then bleach the negative.

MULTIPLE EXPOSURE/ CAMERA CREATIONS/COLORED GELS

In image 5 on page 153 and images 1 and 3 on page 154, Simon Tomlinson and I were experimenting with one of his camera creations—a Holga adapted to shoot instant peel-apart film. By using a different-colored gel in front of the lens for each exposure, we made some really creative and unique images.

LONG EXPOSURE/COLORED FLASH/ HOLGA MOD

I wanted to show what could be done with colored flash and a kind of multiple exposure. I say *kind of*, as there's only one exposure, but because of the multiple flashes and the long exposure, the result (image 7 on page 155) looks like a multiple-exposure shot. The Holga mod is a makeshift cable release with an elastic band to hold the shutter button down to allow for the long exposure.

PAPER MASKS/COLORED FLASH/ MULTIPLE EXPOSURE/LONG EXPOSURE

Image 2 on page 154 uses a few different techniques, three of them by design, and one by mistake. I used a paper mask in my Holga to frame the shot and different-colored flashes with multiple exposures to add interest to the images. I didn't realize that I'd left the "bulb" switch on, and this caused the long exposure, but I really liked the effect. So I was happy.

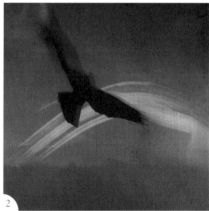

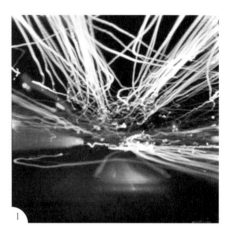

PINHOLE CAMERA/LONG EXPOSURE

One of the things I wanted to shoot for the
long exposure section was light trails from
cars. Rather than keeping the camera still
and waiting for the lights from cars to pass
the camera, I thought it would be interesting
if I mounted a pinhole camera to my car and
let the camera pass the lights from cars and
streetlights. Because of the small aperture
that pinhole cameras have, they're perfect
for this. (See the results in image 8 on page
155 and image 1 on this page.)

UNDERWATER PHOTOGRAPHY/
PUSH PROCESSING

Because water absorbs light, it is advisable not
to use a fast film for underwater photography.
I knew that I wanted a very contrasty and
grainy effect for images 4 and 5 on page 155,
so rather than using a faster film, I decided
to push a slower film to the speed at which
I wanted to shoot. It gave a different effect
from the usual underwater photography.

PAPER MASKS/SOLARGRAPHY

For this fantastic shot (image 2 on this page),
the photographer used a variation on the
paper mask project. Instead of masking
a big portion of the frame, he used little
cutouts of a bird to mask just a small section.
He combined this with solargraphy to create
some beautiful images.

Essentials on ...

FILM TYPES

PRINT FILM (COLOR NEGATIVE)

Print film captures the image in color and produces a negative image from which prints can be made. There are many types available. But don't think that all color films are the same. Some are great for skin tones, some for landscape and nature, some produce highly saturated rich colors, and some desaturate color, making it less vivid or washed out. The best thing to do is to shoot as many different types of film that you can, and find the type that suits you and your style.

Taken on Fuji Reala, which is good for natural colors (Adam Bronkhorst)

You can get low-cost or unbranded film free when you get a film developed, or find it in discount stores. It's often the lowest-grade film on the market, but it can produce some unusual results.

Consumer-grade film, such as Kodak's Ultra Max and Gold and Fuji's Superia, is intended for mass production. It's a jack-of-all-trades film and produces good all-around results in most conditions. It can be great for holidays, capturing people, sky, action, and landscapes effectively.

Taken on Kodak Portra 400VC, producing vibrant colors
(Adam Bronkhorst)

Then there's top-grade, professional color film. Different types are designed for specific purposes. One type might produce great skin tones and is perfect for portraits or shooting people; another type might be great for landscape photography. As you'd expect, the general quality of these films is far superior to consumer films, and of course, these will cost you a lot more.

DEVELOPING

The process for developing color films is known as C41. Almost all labs that process film will be able to handle C41 processing. If you look, you should see C41 written on your color negative film canister.

ISO

Film's sensitivity to light is measured in ISO values. The lower the value, the less sensitive the film. So if it's a bright, sunny day, shoot on ISO 100 film. This allows you to use a relatively normal shutter speed and aperture size. If it's a dull, overcast day, ISO 100 won't be sensitive enough and you'll need more light to get the right exposure. Trying a slower shutter speed or a bigger aperture can work, but your image could be blurry. Using ISO 400 is a better bet. For really low light, you can easily get film that has a sensitivity of up to ISO 3200.

SLIDE FILM

Slide film produces a positive, rather than negative image on a transparency. It also has richer, deeper color saturation than color negative, and higher contrast than negative film. That's why professional photographers taking images for large-scale print work sometimes prefer it. But there's a trade-off, in that you need to have more control over your exposure when shooting.

Taken on Fuji Sensia 200 slide film for richer colors (Adam Bronkhorst)

DEVELOPING

The process of developing slide film is called E6. This will be written on the side of the film canister or roll. E6 is an expensive and specialist process, which few labs offer. A more common way of using slide film is to shoot on film that's meant to be processed as E6, but to develop it in C41 chemicals. This is known as cross-processing, and it's covered in more depth on pages 034–039.

Taken on Fuji Sensia 200, known for its bold colors (Adam Bronkhorst)

COLOR FILM

ALL-AROUND
One of my personal favorites is Kodak Portra 400. This film works well in almost all types of cameras, from small point-and-shoots to Holga, Diana, and other medium-format plastic cameras. I shoot a wide range of subjects, so I look for a good all-around film. Kodak Portra 400 is great with skin tones and has exceptional color saturation in a wide range of lighting conditions. It also has very fine grain, so it's ideal for scanning.

SHOOTING PORTRAITS
Some films can make skin look really red. This isn't flattering for anyone, so if you're shooting a lot of people or portraits, have a look at Portra 160NC film—the NC stands for natural color. Other good films to try for portraits are Fujicolor Pro 160S and Fujicolor Pro 400H.

VIVID COLOR
For vivid, enhanced, and saturated colors, try Kodak Portra VC160 (the VC stands for vivid color) or Kodak Ektar 100.

BLACK-AND-WHITE FILM

Black-and-white images can have a special atmosphere and quality. But don't think that shooting in this medium is easier than shooting in color—it can be a lot more challenging. That's because a lot of the information that color photography provides for the viewer just isn't there in a black-and-white image. You really need to concentrate on tone and composition. Start seeing in shades of gray. A bright blue and bright red, though strikingly different colors in real life, could have the same tone, and will therefore look very similar in black-and-white photography. Think about light and shade. Is everything of a similar balance? Or does your image have a range of dramatic features that will translate well in black and white? Use shadows, form, texture, lines—anything you think will work well in monochrome.

Taken on Kodak TRI-X 400 (Adam Bronkhorst)

STORAGE

Films are like food—they have a use-by date. So refrigerate your film to keep it fresher longer. Once you've exposed a film, keep it cool, and try to get it processed quickly. Developing is designed to get the most realistic colors or interpretation that the manufacturer intended. Film is covered with a layer of chemicals (or emulsion), and as soon as this is exposed to light, these chemicals start to change. The longer you leave developing, the greater the risk you won't get the result the manufacturer intended. Unless, of course, you want to experiment! You could leave a film lying on a warm windowsill for a few months to see what happens, but otherwise, refrigerate right away and get down to the lab as soon as you can! (For more on using expired film, see Expired Film on page 163.)

The texture you often see in black-and-white photographs is called grain. It's caused by miniature particles of black metallic silver in the dark areas of the image. The faster or more light sensitive the film, the coarser and more obvious the grain will be. So for really deep blacks with less grain, you should shoot with a film that has a low ISO value. If you want lots of grain, go for a higher ISO value.

BLACK-AND-WHITE FILM

KODAK TRI-X 400
Fantastic for taking portraits

ILFORD HP5
A brilliant black-and-white film for a Holga

ILFORD FP4
ISO 125 is great if you're looking for a slower film

FUJI NEOPAN 400
Gives really great blacks

FUJI NEOPAN 1600
A great fast black-and-white film if the light's very poor

DEVELOPING
Your local supermarket probably won't be able to process black-and-white film, so you'll need to find a lab that can. This can be expensive. But the good news is, developing black-and-white film is pretty straightforward, so some photographers do it themselves at home (see pages 040–043). XP2 by Ilford can be processed in C41 chemicals just like color film, though I find it can produce a very flat image with not much depth of tone.

Taken on Fuji Neopan 400 (Adam Bronkhorst)

INSTANT FILM

There are two types of instant film available. The first is integral film, for which all the chemicals needed to develop and fix the image are contained in the layers of the film itself. You don't need to do anything apart from take the shot, and your instant photo magically appears. The second type is peel-apart film. After the shot's been taken, you pull the film out of the camera through rollers, which spread a compound between the exposed negative and the positive sheet. This kicks off the development process. You leave your photo to develop for a predetermined time, depending on the temperature of your surroundings. Then you peel the positive sheet away from the negative to reveal the developed photo.

POLAROID

Polaroid started selling instant cameras in 1948 and became the best-known manufacturer, producing some beautiful models. The most recognized Polaroid instant film is the square-format 600 film, adored by photographers and artists worldwide. Sadly, Polaroid stopped producing instant film in 2008. But you can still find it on eBay and other websites. Packs sell for extortionate amounts of money, though, and are now mostly out of date.

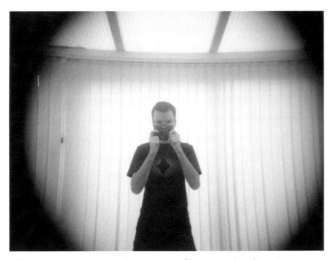

Taken on Fuji FP-100C peel-apart instant film (Simon Tomlinson)

EXPIRED FILM

Expired film has gone past its recommended use-by date. Results vary, depending on how the film has been stored. Sometimes you'll get colors that are way off what they were when you shot them. Sometimes there'll be high, little, or hardly any contrast, or the images will be very grainy. Occasionally, you'll get nothing at all! That's the appeal of expired film for some photographers—you never know how your film will turn out.

How expired is too expired? That's for you to find out. I've heard of people shooting film that's out of date by up to 40 years. You can get expired film from internet auction sites, and some photography shops and processing labs have a bin of cut-price expired film. The switch to digital means that people want to get rid of old film and sell it, too. I've picked up my best bargains from garage sales. That's the other main attraction of expired film—it's usually cheaper than nonexpired film, especially if someone's selling a bulk load.

THE IMPOSSIBLE PROJECT

A few brave souls, including the former head of film production at a Polaroid factory in the Netherlands, have teamed up to resurrect this classic film format. The self-named Impossible Project teamed up with Ilford Photo and leased the last Polaroid production plant. They're now producing several types of instant film for Polaroid cameras. At the time of writing, there are two kinds, Silver Shade and Color Shade. Although they're far from stable, and results can be unpredictable, it's a giant leap in the right direction.

FUJI PEEL-APART

If you're looking to use instant film in a big way, I'd highly recommend looking at the range of films that Fuji produces. The great news is that Fuji's peel-apart pack films can be used in lots of Polaroid cameras that take peel-apart film, and in most instant camera backs that take it.

Fuji produces color and black-and-white peel-apart film in silk and gloss finish. I'd recommend you use the gloss, as I've had problems scanning the silk film due to the texture of the final photograph.

FUJI INSTAX

This integral film develops the pictures in front of you, right after coming out of the camera. There are two versions of this film: Fuji Instax Wide Picture Format, which is a landscape format and measures 4¼ × 3⅓in (10.8 × 8.6cm), and Instax Mini, which produces wallet-size pictures measuring 2½ × 1¾in (6.5 × 4.6cm). The wonderful thing about these Instax films and cameras is that you can still buy them new!

There are instant backs available for other cameras, such as the Lomo LC-A and Diana, with which you can use Instax. It's a great way to add new life to these cameras. But be warned that at around ISO 800, Instax is a fairly high-speed film, so results can be overexposed if the camera isn't ISO-aware.

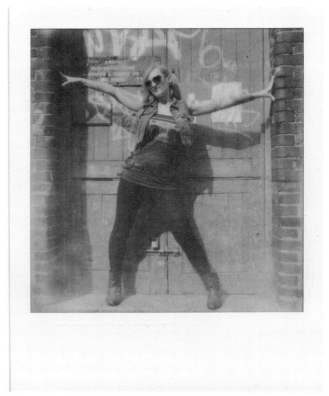

Taken on Impossible Project Color Shade (Andy Wilson)

Essentials on …
FILM FORMATS

35MM FILM

Introduced by Kodak in 1934, 35mm film (also known as 135 film) is the most popular format on the market. Thankfully, you can still buy it everywhere—online, in supermarkets, camera stores, drug stores, and at tourist hotspots. Almost any lab that processes film will be able to process 35mm, including most supermarkets. There's a wide variety of film types available in this format such as color negative, color and black-and-white slide, and black-and-white. Because it's so easy to buy and process, and lots of cameras support this format, this is your place to start. Go shoot something with 35mm film, now!

120 FILM

Kodak introduced 120 film for their Brownie No. 2 way back in 1901. It makes a bigger negative than 35mm film, so you get more detail when you're enlarging. You can easily buy this film online and from most good camera stores or labs, although you probably won't find it in supermarkets or convenience stores.

This film comes in a roll, with a paper backing to stop light from exposing the film. You can get anywhere from 3 to 16 exposures from a roll, depending on your camera type and how it's set up. The most common way of shooting 120 film, particularly with toy cameras, is in the square format, resulting in 12 exposures per film.

220 FILM

Don't confuse 120 with 220 film, which is essentially the same type of film but doesn't have any backing paper. The upside of this is that you can take double the shots on a roll, as the space normally taken up by the backing paper is used to add double the amount of film. But there are two downsides. First, the backing paper that stops light from entering the camera isn't there, and second, the frame numbers aren't printed on it either. So, with 220 film, you need to block the film counter window to avoid a massive light leak, and you also need to keep a careful track of where you're at when shooting, and be prepared for a little light creeping in.

Essentials on …
PRINT OPTIONS

PRINT SIZES

Prints come in standard sizes including 6 × 4, 7 × 5, and 8 × 10. The 6 × 4 size is a 3:2 ratio, 7 × 5 is a 3.5:2.5 ratio, and 8 × 10 is a 5:4 ratio. Your image may be cropped by the lab, depending on the size of print you go for. It is much better to crop it yourself in photo-editing software. Don't let someone else crop your image where they think is best.

MATTE OR GLOSS

This is totally down to personal preference. Glossy prints can bring out colors and contrast more than matte; matte is better for framing and albums, as you're less likely to show fingerprints and you'll get fewer reflections. But gloss is better for scanning, as your scanner may pick up the texture of the matte paper.

BORDERS

To border or not? I quite like white borders, as they add a sense of nostalgia and frame the image. However, if I think I'll scan my print, I'll get it without borders to enable me to get the most amount of information on the print. Again, this is totally down to your own preference.

TYPES OF PRINTS

DIGITAL C-TYPE
In C-type printing, a digital scan of your negative is projected onto light-sensitive paper with photosensitive emulsion. Most C-type mini-labs now project the image onto the paper with lasers or LEDs rather than with a traditional bulb. This is the most common type of print.

INK-JET
Most photographic images above 12in (30cm) wide will be printed using a specialist ink-jet printer. This is very similar to the printer that you may have with your computer. It feeds paper through and prints out the image in linear strips. Anyone can buy one of these machines and start printing for themselves, as they're very affordable now. However, the real skill a photo lab brings to these types of prints is the color management of the system and your images. They should also use better-quality inks and papers.

GICLÉE
Giclée printing is often used by illustrators and artists who want accurate reproductions of paintings and drawings and is good if you want a look that isn't too photographic. Giclée uses a wider variety of paper types and surface textures. You'll only get this type of print in labs that are set up for specialist printing.

OTHER OPTIONS
If you want to display your images for an exhibition or at home, there are other options to consider, such as wood block, aluminum or acrylic mount, and Dibond. You need to go to a specialist lab that offers these services. Lots of labs also offer services like printing onto canvas, coffee mugs, key rings, mouse pads, and the like.

Polaroid 600 SE, Fuji FP-100C (Wendy Laurel)

Essentials on ...
PHOTO LABS

FINDING A LAB

There are lots of different labs out there—everything from your big supermarket lab that churns out snapshot after snapshot, to the local independently owned processing lab, which I prefer. They often welcome more unusual requests and are very knowledgeable about photography. Of course, you may not have a lab nearby, so in that case, find one that can accept mail orders. If you're doing anything out of the ordinary (like push or pull processing—see pages 030–033), this would be your best bet.

If you can't find a mail-order lab, look for recommendations on photography forums or ask people on Flickr.com. You'll find they'll be very helpful.

USING A LAB

Always give the lab as much information as possible about what you want. Give them a call, and make friends with your lab technician. It'll help you massively along your analog journey.

If you're doing anything out of the ordinary or unusual, please, please, *please* tell your lab technician. You don't want their machines automatically adding color correction to your cross-processed images. And you definitely don't want any of those gorgeous panoramic images (see pages 102–107) chopped up by mistake.

If you want to cross-process your films, get a permanent marker and cover up the bit on the film canister where it says to process the film as E6. Even if you know your lab technician, it may not be them processing the film itself, so I usually cover mine up to avoid any confusion. If I've pushed or pulled a roll of film, I'll also write that on the canister, as it's very easy to forget. That way, there's no confusion.

If the lab technician knows what you're trying to do with your film, they can keep an eye on it when it's processed and correct any mistakes that may have occurred.

GETTING YOUR FILMS BACK

I always leave my phone number with the lab, just in case. I also make sure that I check the contact sheet and negatives at the lab. It's a lot easier to point out something that's gone wrong then and there than checking when you get home.

Generally, I get my films developed and scanned to disc rather than made into prints. It's much easier for me to get my images onto my computer if the lab scans the negatives when developing. The lab is also probably going to have a better scanner than I do.

It can sometimes be cheaper to just get processing and scanning without prints than it can be to get processing and prints. I'm also not left with a massive pile of prints from all the films I've had developed. And this is my favorite: you have an instant backup copy of your images on disc once you've downloaded them to your computer.

Essentials on …

JARGON

aperture
The opening in the lens through which light travels. The amount of light is measured in f-stops.

barrel effect
The distortion of an image produced by the lens that causes straight lines to bulge and bow, giving a barrel-like appearance.

bracketing
Taking three or more different exposures of an image to ensure you get the perfect exposure. You usually take one as recommended by the light meter/camera, one a stop over, and one a stop under.

color space
A geometrical system of representing colors in terms of measurable value, such as the amount of red, green, and blue in an image. Adobe RGB and sRGB are the most commonly used color spaces in digital imaging.

contact sheet
A sheet of very small versions of all the images from a roll of film. Developing labs often produce these and supply them with processed film to enable the photographer to see at a glance which images are on the film.

dpi
Dots per inch. A measurement that defines in how much detail images are scanned, printed, or saved.

flickr.com
This is a social network site for photographers and a fantastic source of information and inspiration. If you're not on Flickr, you really should be. Connect with fellow photographers, join in or search discussions about any aspect of photography, upload your images to the site, and much more.

film grain
Fine silver crystals in the light-sensitive emulsion of the film react when exposed to light and turn black, producing "grain." The slower the film, the finer the grain; the faster the film, the coarser the grain.

ISO
The measurement of how sensitive film is to light.

light leaks
Light leaks occur when an unexposed film or part of it is exposed to any amount of light. A whole film can be ruined, or it may be that part of the shot is obscured by "fogging." Holga cameras often suffer from light leaks, but some photographers like the effects they cause and welcome them.

lightproof bag
A specialist tool for photographers to allow them to work on light-sensitive material without the use of a darkroom.

metallic silver
A light-sensitive chemical used in photography papers and films.

neutral density filter
A colorless or gray filter that fits over the lens. This allows the photographer to reduce the amount of light entering the camera without affecting the color of the image.

photo-editing software
Any software that you can use to edit your images, such as Photoshop, Lightroom, Aperture, iPhoto, and Paint Shop Pro Photo.

rule of thirds
A compositional rule; the image can be divided into nine equal parts by two equally spaced lines horizontally and vertically. You can place objects of interest along these lines or at their intersections.

shutter speed
The speed at which a camera's shutter opens to allow light onto the film.

silver halide film
Silver halide is the light-sensitive chemical compound used in photographic paper and film.

swing lens
A lens that rotates around a central point in a camera. It's aligned with the axis of the lens and exposes a strip of film along its curved film plane. These lenses usually have a field of vision between 110° and 140°.

UV filter
A filter applied to a lens, which has little or no impact on the exposure of the shot. Because of this, these filters are usually used to protect the lens itself.

vignetting
The reduction in brightness at the edges of an image, caused by the camera's optics.

white balance
The balance of red, green, and blue needed to produce a normal-looking white. Digital cameras have this as a built-in function, and some films are balanced for different situations. Different lighting conditions produce different white balance.

CONTRIBUTORS

ODDGEIR AUKLEND
oddgeirauklend.com

Oddgeir discovered analog photography in 2008, solargraphy in 2009, and, by the end of 2010, he had over 100 cameras.

CHRIS DEAN
graphicinvasion.com

Chris, a graphic designer, bought his trusty secondhand LC-A in St. Petersburg, Russia, and baffled his peers when he exhibited blurry and low-quality prints at his degree show.

ERICH HUBL
flickr.com/photos/eokgnah

Surrounded by high-tech digital equipment, Erich finds comfort and contrast in the imperfect world of analog photography and is hooked on the completely DIY process of solargraphy and waiting for a picture to develop.

ADAM BRONKHORST
adambronkhorst.com

Adam believes it's not the camera that takes the photo; it's the photographer who makes the photo. He is at home using a big DSLR or his phone, studio lights or daylight—anything that can capture an image.

LIANA GARCIA JOYCE
flickr.com/photos/golfpunkgirl

Liana is obsessed with analog cameras and her life revolves around photography. (She even met her husband through Flickr!). She is part of the Lomography UK team as shop manager of the London Soho store.

GRAHAM LALLY
exmosis.net/photos

Graham enjoys playing with eclectic and idiosyncratic devices, from bargains to box cameras, and SLRs to solargraphy.

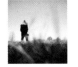

DARREN BURTON
dazb.co.uk

Darren has been addicted to film photography since 2008. He enjoys photographing cats, airplanes, derelict buildings, self-portraits, and anything that catches his eye.

LISA GARNER
flickr.com/photos/lissyloola

Lisa, a graphic designer, enjoys finding interesting patterns, shapes, and colors. She's been shooting double exposures since 2007, as she finds it a unique way of capturing iconic landmarks on her travels.

WENDY LAUREL SHEVELAND
wendylaurel.com

Wendy is a fine-art photographer. She shoots 100 percent film in many formats: medium, 4 × 5, 35mm, toy camera, and Polaroid.

NHUNG DANG
nhungsta.com

As a self-taught photographer, Nhung has an experimental approach, working with a variety of cameras and techniques. Her favorite is a pinhole camera fashioned from a cookie tin.

CHRIS HARRISON
curiouseye.tumblr.com

Chris is a graphic designer who uses photography to keep his creative juices flowing. Most of his images are based on strong graphic compositions and colors that look very nice together.

JASON LUPI
flickr.com/people/jasonlupi

With a fine-art background, Jason incorporates multidimensional and mixed media in his work. Film photography enables him to use similar techniques, including homemade masks and multiple exposures.

MICHAŁ MAŁKIEWICZ

malkiewicz.art.pl

In the mid-2000s, Michał began taking photos on various photosensitive materials with pinhole photography. He likes to experiment with different camera designs and techniques.

MIKE ODDHAYWARD

oddhayward.com

Mike likes shooting with all kinds of film cameras to avoid spending too much time in front of a computer screen. He also fixes up old cameras because they are irreplaceable and beautiful machines.

SIMON TOMLINSON

flickr.com/photos/simontomlinson

Since discovering toy cameras and pinhole photography, Simon dreams about dismantling and reassembling cameras "wrong" to create unique images.

KEVIN MEREDITH

lomokev.com

lomokev is well known for his Lomo LC-A work but is no stranger to digital technology. The author of three photography books, he also teaches regular photography courses.

NATHAN PASK

nathanpask.com

Primarily a fashion and portrait photographer, Nathan has been involved in all sorts of projects, from still life and advertising to live music and architecture.

ANDY WILSON

fatreg.net/portfolio

Andy's passions are vintage and toy film cameras and photographing models. He develops most of his own film, with a reckless attitude to timings, temperatures, dust, and cat hairs.

SARAH MEREDITH

rockcakes.com

Photography is a hobby for Sarah, and it also influences her Rock Cakes jewelry work. She loves shooting on film and cross-processing in particular.

BORIS H. POPHRISTOV

pophristov.com

Boris is a rising nature photographer. He started with digital but fell madly in love with film and pinhole.

BETH WILSON

beth-wilson.co.uk

Beth has a photography degree and developed a love of everything analog while at college. She loves to shoot all sorts of things, but no film is developed without at least a few cat photos on it.

INDEX

Figures in **bold** refer to captions

ACKNOWLEDGMENTS

Without all the contributors, this book wouldn't be what it is—something I'm very proud of. Thanks especially to Lisa Garner, Sarah Meredith, Graham Lally, Darren Rogers, Jason Lupi, and Wendy Laurel Sheveland, who all helped out above and beyond the call of duty.

Thanks to Mike Oddhayward for checking some sections and for a wonderful day spent in a darkroom. Andy Wilson for checking other sections, the loan of some cameras, and for being a film hero. Simon Tomlinson for being a camera genius and taking film photography places that I didn't think were possible. Jim Stephenson for checking more sections, being a great listener, and helping out with more than just this book. Kevin Meredith for always being there, including me in one of his books, the loan of cameras, great advice, and inspirational photography.

Thank you to: Colourstream for indispensible advice and fantastic processing over the years; The Vault for their processing; Clock Tower Cameras for the advice and loan of some gear; Fred Aldous, for supplying me with film; Incognito for sending me a big box of film and camera goodies to help with the book. *colourstream.net; thevaultimaging.co.uk; clocktowercameras.co.uk; fredaldous.co.uk; incognito-uk.co.uk*

Huge thanks to Isheeta Mustafi for making the book happen. Lindy Dunlop, for fantastic advice throughout this journey. Rachel Giles, the best editor that I could have hoped for. And everyone else at RotoVision.

Everyone who has appeared in a photo in this book, I'd love to name you all, but it would be a very long list. You know who you are.

Thank you to friends and family for letting me take their photographs all the time, and to anyone I've ever photographed.

Thanks too to Jill and Bryan for letting me stay for a great week, and Spencer for driving 16 hours to see me. Fletcher, next time. The rest of my American family for making me feel so at home.

I'd like to thank my mum, dad, and little sister for all the love and support they've ever given me. You made me who I am.

My two beautiful kids, Alfie and Ava. You make my life complete.

My rock. My love. My wife. Without you, I'd be nothing.

First published in the UK in 2012 by Apple Press
7 Greenland Street
London NW1 0ND
www.apple-press.com

10 9 8 7 6 5 4 3 2 1

Manufactured in China by 1010 Printing International Ltd.

ISBN: 978 1 84543 425 0

Art Direction: Emily Portnoi
Design: Emily Portnoi
Layout: rehabdesign